HENRI MATISSE

SUSAN A. STERNAU

TODTRI

This book was designed and produced by
Todtri Productions Limited
P.O. Box 572, New York, NY 10116-0572
FAX: (212) 279-1241

Printed and bound in Italy

ISBN 0-7651-9248-9

Library of Congress Catalog Card Number 97-066063

© 1997 Succession H. Matisse, Paris/Artists Rights Society (ARS),
New York

Author: Susan A. Sternau

Publisher: Robert M. Tod
Editorial Director: Elizabeth Loonan
Book Designer: Mark Weinberg
Senior Editor: Cynthia Sternau
Project Editor: Ann Kirby
Photo Editor: Edward Douglas
Picture Researcher: Laura Wyss
Production Coordinator: Jay Weiser
Desktop Associate: Paul Kachur
Typesetting: Command-O Design

Picture Credits

Albright-Knox Art Gallery, Buffalo, New York 20, 84

The Art Institute of Chicago 67, 103

The Baltimore Museum of Art 32, 35, 98

The Bancroft Library, University of California, Berkeley 124

The Barnes Foundation, Merion, Pennsylvania 28, 94, 95

The Bettmann Archives, New York 99, 119, 125

École des Beaux-Arts, Paris—Art Resource, New York 111

The Hermitage, St. Petersburg—Art Resource, New York 21, 27, 29, 36, 37, 43, 46, 47, 55, 63

International Museum of Photography at George Eastman House, Rochester, New York
7, 58, 66, 76, 79

Isabella Stewart Gardner Museum, Boston 25

Magnum Photos, Inc. 116

Musée d'Art Moderne, Paris—Art Resource, New York 8, 14, 24, 34, 80, 81, 87, 89, 97, 127

Musée des Beaux-Arts, Bordeau—Art Resource, New York 22

Musée Georges Pompidou, Paris 114–115, 117, 120–121

Musée Matisse, Nice—Art Resource, New York 108

Musée de l'Orangerie, Paris—Art Resource, New York 83

Museo de Arte, São Paulo—Art Resource, New York 101

The Museum of Modern Art, New York 9, 11, 17, 18, 19, 31, 33, 39, 40, 41, 44, 45, 50, 51, 53,
60, 64, 69, 71, 73, 74, 77, 78, 82, 88, 90, 92, 93, 100, 104, 105, 107, 112, 118, 123

The National Gallery of Art, Washington, D.C. 113

Philadelphia Museum of Art 102, 106

Pushkin Museum of Fine Arts, Moscow—Art Resource, New York 6, 12, 48, 49, 52, 56, 57,
59, 72, 75

Tate Gallery, London—Superstock, New York 5

CONTENTS

INTRODUCTION

eductive bright colors unlike any that had come before, and the poetry of the human figure reduced to a mere essence of line and shape—created with a few sheets of cut and pasted colored paper—define the legacy of Henri Matisse to twentieth-century art. Matisse's life was marked by steady, industrious work and a constant seeking and reevaluation of his creations.

He was first and foremost an artist devoted to the human figure—with a far-reaching understanding of the expressiveness of the female nude, the subject he favored. He celebrated the curves of the female form repeatedly throughout his life, at times achieving a brilliantly expressive and lyrical line to convey both form and movement, at other times distorting the forms of the body for their expressive potential. The style of Matisse's art, rather than the often conventional subject matter, reveals the originality of his creativity and vision.

Matisse's search for a style of his own introduced intense, nonnaturalistic color into painting and put him at the forefront of Fauvism, the early twentieth-century development that is considered to be the first advance of the modern movement in painting. His continued struggles with self-expression gave to the world, over some six decades, a wealth of new and original visions in color, line, and form. If the young Matisse had not abandoned a safe career in law for the uncertainty of one in painting, the way art was seen and made in the twentieth century might have been very different. With the exception of Pablo Picasso, no other artist has so profoundly and single-handedly shaped the direction of modern art.

Matisse's career as an artist was shaped by his delight in the visible world. The colors and forms of his environment presented a continual challenge that led him to constantly experiment with new styles. He quickly moved from the dotted brushwork of Neo-Impressionism to the bold expressions of Fauvism—then left Fauvism behind for a monumental decorative style characterized by simplified color and design. He drew inspiration from ordinary human experiences such as music and dance for his great commissioned mural decorations. The objects in his studio took on pulsing life and vigor in his still lifes as he filled his compositions with patterns, arabesques, and bold colors. Several trips to Morocco further inspired him to create images of enduring appeal—focusing on the people, buildings, and light of this new environment.

During the trauma of the First World War, Matisse's works became for a time darker and more analytical. His friendship with Picasso and other Cubists led him to experiment briefly with the rigors of Cubism, although he never fully embraced the style. His portraits of this period have a transcendent quality—as if he was seeing the lives of those around him with a particular clarity of vision brought on by the state of living in a world at war.

Then, between the wars, Nice became a refuge where Matisse immersed himself in a sensual fantasy of odalisques and idylls,

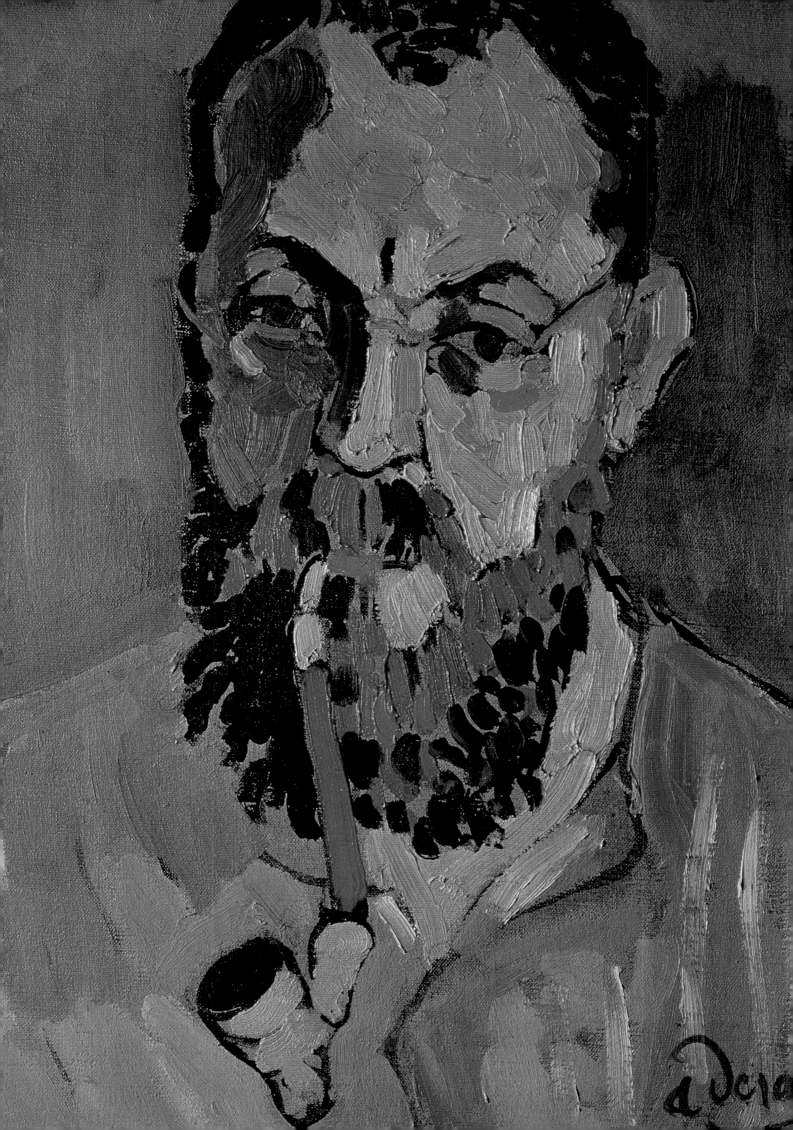

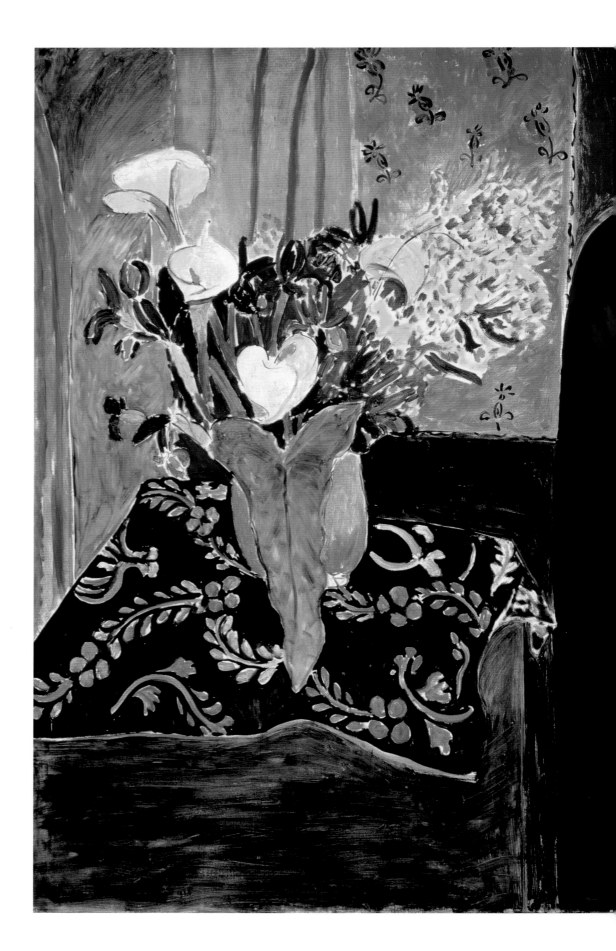

**Calla Lilies,
Irises, and
Mimosas**

*1913, oil on canvas,
57¼ x 38¼ in.
(145.5 x 97 cm).
The Pushkin Museum
of Fine Arts, Moscow.*
Painted in Tangier,
this appealing still
life of an abundant
bouquet is filled with
pattern and light.
A simple tabletop
in the corner of a
room is transformed
by the artist into a
little taste of paradise.

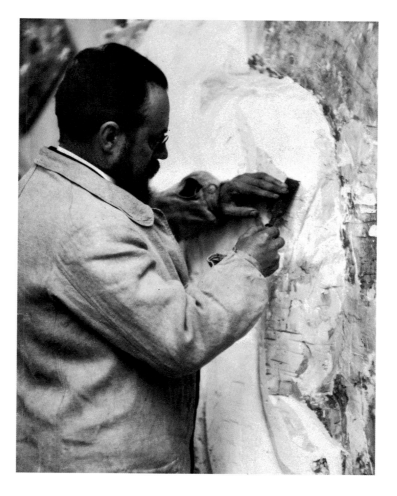

creating paintings that seem almost overfilled with patterns and everyday detail compared with his preceding work. By the later 1930s, though, he was reacting against his own style again with increasingly bold and stylized images. His paintings of woman in interiors of this time are composed so as to give great animation and importance to everything from the model's faces to their armchairs and the potted plants behind them.

Toward the end of his life, illness and an operation from which he almost did not recover left Matisse in an increasingly frail condition, and weakened muscles prevented him from standing for more than a few minutes at a time. No longer able to work at an easel, he was forced to invent a new method of "painting." He began making cutouts of colored paper, using the scissors as a combination of brush and sculpting tool. He also further simplified line, partly by necessity, by drawing from a distance using charcoal attached to a long bamboo pole.

Almost by accident, Matisse fell into the project of decorating the Dominican Chapel at Vence, for which he created some of his most movingly spiritual and simplified work. Working from his bed in his final years, he produced giant cutouts of unparalleled color and expressiveness—as though being freed from the mechanics of painting somehow allowed him to transcend substance with works that are the essence of light, joy, and hope. In this way Matisse finally moved beyond the object, to which he had been tied throughout most of his life and career as an artist. It is not that these last works are abstract, although some of them verge on abstraction, but rather that they reduce the natural world to a universal language of signs and symbols, arabesques and brilliancies, that expresses so much more than literal representation could ever achieve.

Matisse in His Studio at Issy-les-Moulineaux at Work on *Back (II)*
May 1913, photograph by Alvin Langdon Coborn. International Museum of Photography at George Eastman House, Rochester, New York. Matisse often painted his sculptures, incorporating them as part of his still life compositions, and he would sometimes sculpt his problems in painting.

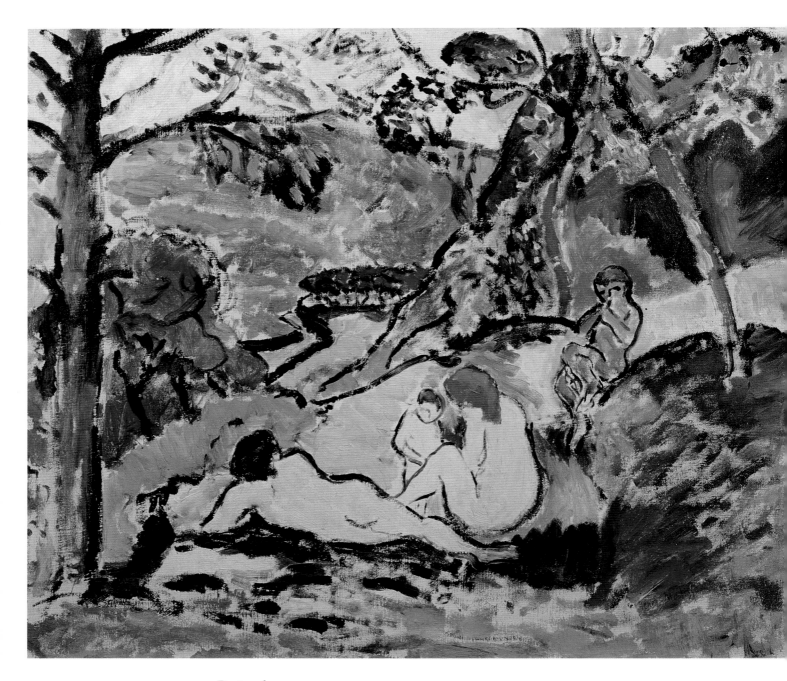

Pastoral

1906, oil on canvas; 18⅛ x 21⅝ (46 x 55 cm). Musée d'Art Moderne, Paris.

After completing the monumental *Joy of Life*, Matisse remained entranced with the theme of nudes in a landscape. This bucolic scene depicts a kind of classical Eden in which two women and a child relax in a hilly wood to the strains of the pan pipes. The palette of blue, green, earth and flesh tones signals a return to the model of Cézanne and a temporary abandonment of bright Fauve color.

Chapter One

YOUTH, EDUCATION, AND EXPERIMENTS IN STYLE

On New Year's Eve at eight o'clock in the evening of the year 1869, Henri Matisse was born in the house of his mother's parents in the old wool-manufacturing town of Le Cateau-Cambrésis, located in the far north of France near the Belgian border. The landscape of this region, known as Picardy, was flat, dreary and damp, an area devoted to the production of sugar beets, flax, and hemp. The nearest town of note was Saint-Quentin, and the nearest city, Lille. Being so close to the border of Germany, as well, the region was subject to invasion during times of war, and had suffered in this way since Roman times, with occurrences during Matisse's lifetime during the Franco-Prussian War of 1870, the First World War, and the Second World War. With the region's habitual exposure to battle, burning, pillage, and plunder, the people of Picardy are known for a stubborn strength that has seen them through hard times.

THE EARLY YEARS

Baptized Henri-Émile-Benoît Matisse in the Church of Saint-Martin in this predominantly Roman Catholic country, Matisse was his parents' first child. He is thought to have been well behaved but sickly, possibly suffering from ulcerative colitis. His mother had two more boys, Émile-Auguste, born two years after Matisse, who died before age two, and Auguste-Émile, born in June of 1874, who grew up to follow in his father's footsteps and become a businessman. Matisse's father, Émile-Hippolyte-Henri Matisse, who had begun his career in business as a linen merchant in Paris, set up business as a grain merchant and druggist in Bohain-en-Vermandois (near Le Cateau). Commerce was in his background, and his business prospered and provided his family with a comfortable middle-class income.

The Artist's Parents

Before 1910, photograph. The Museum of Modern Art, New York. Matisse's father, Émile-Hippolyte-Henri Matisse, was a successful middle-class grain merchant and druggist. His mother, Anna Héloïse Gérard, came from a family of glove-makers and tanners, and gave him his first box of paints to amuse himself when he was recovering from appendicitis as a young law clerk.

> 66 *Fine art is that in which the hand, the head, and the heart of man go together.* 99
>
> —*JOHN RUSKIN*

Matisse's mother, Anna Héloïse Gérard, had met her husband in Paris, where she had been employed as a milliner. A solid, open-faced woman with clear eyes and a wide, firm mouth, she came from one of the oldest families in Le Cateau—the Gérards had been glove makers and tanners there for many years. Matisse's mother also had an artistic side; in her leisure time she painted decorations on china plates and she also made hats.

Matisse was educated locally, and then at age thirteen was sent on to the lycée in nearby Saint-Quentin for studies in Greek, Latin, and French. He was a good student, and showed some ability in drawing. In the fall of 1887, according to his father's wishes, he went to Paris to study law. The following year, having passed his law examination, Matisse returned home and began work as a law clerk in Saint-Quentin. The work was tedious, requiring him to do the work that is done today by copy machines, that is, making sure that clients' files were impressively bulky by filling them with reams of official paper—on which he would occasionally doodle studies of flowers or transcribe the fables of the classic French writer La Fontaine. Still, it was the beginning of a law career that could have led him on a safe and steady path through life, with a comfortable income.

Perhaps to relieve the boredom induced by this job, Matisse attended early morning classes in the elements of drawing at the local municipal school in Saint-Quentin, which was mostly devoted to tapestry and textile design. That same year, an attack of appendicitis, and possibly also nerves, kept Matisse recuperating for months at his parents' home. It was there that his mother gave him a box of paints to amuse himself and

that his passion for art began. He passed time copying from the colored prints called chromolithographs—provided for that purpose, and consisting mostly of Alpine landscapes.

In June of 1890, Matisse painted his first original painting, *Still Life with Books*, a conventional still life, realistic and solidly executed—showing a pile of old leather-bound books stacked haphazardly upon a white tablecloth. Other still lifes from this period are also painted in the illusionistic tradition of trompe l'oeil. In the year that followed, Matisse became increasingly dissatisfied with law; "other people's quarrels interested me much less that painting," he later recalled. Although his father opposed his giving up the security and respectability of law for the certain poverty of painting, Matisse's convictions and stubbornness prevailed. Upon discovering painting, Matisse's life was no longer dull and anxious, he recalled, but rather filled with the sense, for the first time, of being "free, quiet and alone." The strength of this feeling gave him the power to pursue his dream—to study painting in Paris.

A PARIS EDUCATION

When Matisse set off to Paris in the fall of 1891, he was a sturdy looking young man with his mother's features—clean shaven, with a thick head of wavy reddish hair and a somewhat uncertain air about him. Seven years later, in 1898, at the time of his marriage to Amélie Parayre, he was the picture of Third Empire respectability. Holding his top hat, and dressed in a neat double-breasted coat, and with his full beard, mustache, oval eyeglasses, and stiff stance, Matisse looked the picture of a respectable businessman—not the questing art student

and painter that he, in fact, was.

Matisse went to Paris with a recommendation in hand from Philbert-Léon Couturier, a local painter with connections to the conservative painter Adolphe-William Bouguereau, then one of the shining stars of the all-powerful art establishment of Paris. Matisse registered at the Académie Julian, a private school taught by professors of the École des Beaux-Arts, while preparing for the entrance exam for the École des Beaux-Arts itself, the official school of choice for art students. Although a conservative bastion, the École des Beaux-Arts was the oldest and most prestigious institution of its kind anywhere, and offered great resources, including a vast library, a renowned collection of copies and casts of famous artworks, coveted prizes such as the Prix de Rome, and the company of other gifted students.

Matisse's first impression of Bouguereau was formed when he entered his studio and found him hard at work copying, for the third time and with mechanical craftsmanship, from one of his own successful paintings, *The Wasp's Nest* (which showed a young woman pursued by lovers), while a fawning circle of admirers surrounded him. After a few weeks, Matisse found that Bouguereau's teaching methods were not for him, and clearly the feeling was mutual. He recalled Bouguereau saying to him, "You will never know how to draw," and also that he did not know perspective. After failing the entrance exam for the École des Beaux-Arts in February of 1892, a disillusioned Matisse left Bouguereau's studio. But a visit to the Fine Arts Museum in Lille, where he admired still lifes by the eighteenth-century French painter Jean-Baptiste Siméon Chardin and works by Spanish master Francisco de Goya, bolstered Matisse's spirits and firmed his resolve to continue painting.

To further his education, he joined the group copying from the plaster casts of antique sculpture in the glass-enclosed courtyard of the École des Beaux-Arts. It was there that he heard that the newly appointed liberal instructor Gustave Moreau would take any student into his studio who stood up as he passed by. Matisse followed this advice and received an invitation from Moreau to work informally in his studio.

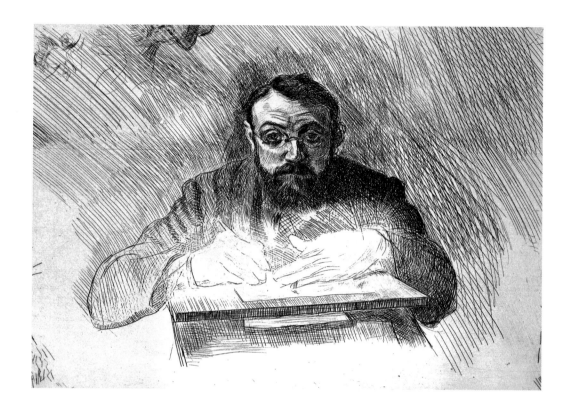

Henri Matisse Etching— Self-Portrait

1900–03, etching and drypoint; 5 5/16 x 7 7/8 in. (13.5 x 20 cm). Gift of Mrs. Bertram Smith, The Museum of Modern Art, New York.

This self-portrait captures the searching intensity and anxiety of Matisse's gaze as he sees himself during his early years of poverty and struggle. The detailed modeling and realistic approach of this etching reflects the many years he had spent drawing from life and plaster casts and copying the works of the Old Masters.

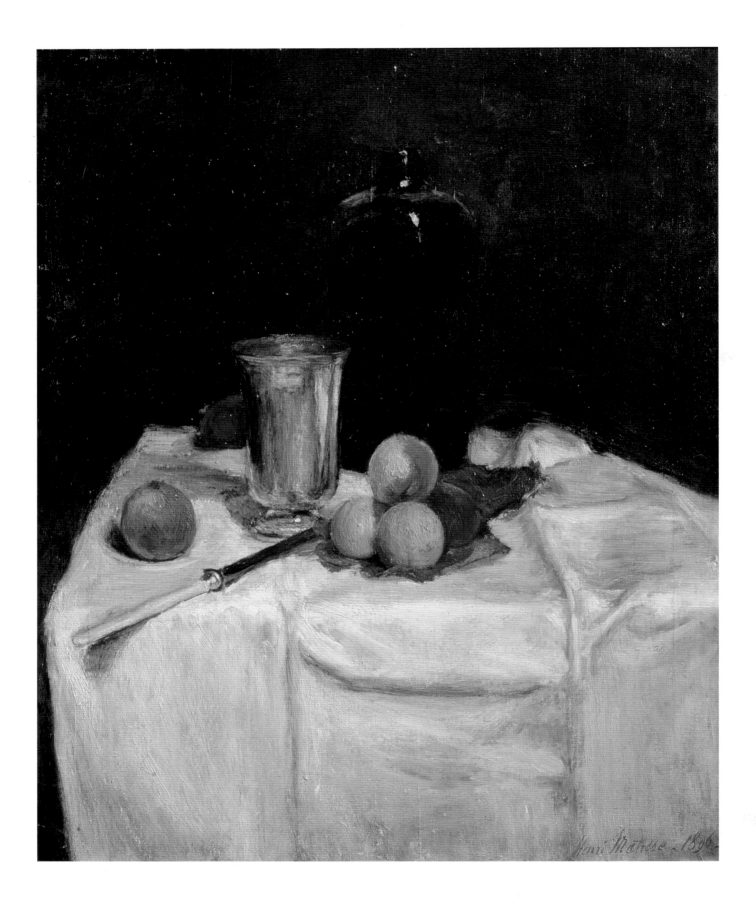

WITH GUSTAVE MOREAU

Entry into Moreau's studio changed the course of Matisse's art education—instead of "copying nature stupidly " as the academics demanded, Moreau encouraged his students to admire a wide variety of fine painters of previous centuries in the Louvre, and also to look for inspiration in the work of contemporaries such as Henri de Toulouse-Lautrec. Moreau did not insist on the endless, precise drawing from casts and models that was the rule of academic teaching of the day, but rather encouraged his pupils to think for themselves and develop their own tastes and vision—by copying works at the Louvre, sketching passersby in the streets and dance halls, or painting from models in the studio. Moreau's own vision as a painter was personal and quirky—he painted figures in elaborate dreamy scenes, rich with feeling, a wealth of exotic detail, and his own personal symbolism.

Matisse's paintings of this period are done in subdued dark colors—he was attracted to a still life called *The Dessert* by the Dutch painter Jan Davidsz. de Heem and obtained permission to copy it. The subject of the remains of a meal adorning a tabletop was popular in France—it struck a chord with Matisse, and he returned to it at various points over the years. In all, Matisse copied over twenty-five works at the Louvre by Italian, Spanish, and Dutch masters, but primarily by French painters of the seventeenth and eighteenth centuries, such as Nicolas Poussin, Antoine Watteau, Jean-Honoré Fragonard, and Jean-Baptiste Siméon Chardin. These copies had a function besides learning; they were bought by the French government to adorn public buildings and thus helped supplement the income of the art students. Some of Matisse's copies were also done for his relatives.

At this time Matisse was also enrolled at the École des Arts Décoratifs, where he took courses in perspective, composition, and geometry to maintain his academic standing. There he met a fellow student, Albert Marquet, who became his friend and companion on sketching expeditions in the cafés, bars, and dance halls—where they competed to see who could render the quickest, most accurate impression. Matisse was also living with Caroline Joblaud, who bore his daughter, Marguerite Émilienne, in September of 1894.

In 1895, three years after his first attempt, Matisse successfully passed the entrance exam and was accepted into the École des Beaux-Arts. He was also officially admitted into Moreau's studio. His painting *The Studio of Gustave Moreau*, done at this time, shows a dim interior with a nude female model in the foreground, who seems to confront and overshadow the plaster cast of a classical nude male figure facing her. Several students are pictured hard at work in this murky study of grays and browns—but the central drama is the confrontation between the two nude figures, which could perhaps be read as a comment on the battle of the sexes.

Also of this period is *Woman Reading*, a sensitive, conservatively painted study of an interior and figure. The theme—a seated woman facing away toward an open cabinet topped with a multitude of still life objects—would, with variations, continue to be part of Matisse's repertoire for many years, although his manner of painting such scenes would alter radically. *Woman Reading*, along with several still lifes and a studio interior, were sent by Matisse to the new, liberal exhibition, the Salon de la Nationale. The works were accepted and shown and several were sold, including *Still Life with Black Knives*. Matisse's

The Bottle of Schiedam

1896, oil on canvas; 28½ x 23⅓ in. (73 x 60 cm). The Pushkin Museum of Fine Arts, Moscow. Matisse's early paintings are often rendered in subdued tones in the tradition of eighteenth-century still life painters such as Chardin. Matisse generally limited the subject to fruit, bread, drink, and accompanying tableware laid on a white cloth covering a dark table. He was still a student in Moreau's studio when he painted this work.

**Le Modèle
(The Model)**

*c. 1898, oil on canvas.
Musée d'Art Moderne, Paris.*
A complete art educa-
tion in Matisse's day
required the student
to learn to draw from
plaster casts of classical
Greek and Roman
sculpture. After attain-
ing sufficient skill,
the student was then
allowed to proceed
to painting from
the live nude model
in the studio.

success at this exhibition earned him an election as an Associate Member of the Société Nationale, nominated by the celebrated painter and president of that society, Pierre Puvis de Chavannes. As a member, Matisse would be now be able to submit work for exhibition without going through a selection or jurying process.

EXPERIMENTS IN STYLE

For all Moreau's liberalism as a teacher, his students had no exposure in his class to the work of the Impressionists or Neo-Impressionists. Their work was generally considered ugly, incomprehensible, and unacceptable by the art establishment of the period, and thus unacknowledged. However, Émile Wéry, a neighboring painter of Matisse's in his new quarters at 19 Quai Saint-Michel had a different opinion of Impressionism—the style of painting fleeting impressions of light in nature as seen in the work of French Impressionist painters Claude Monet and Pierre-Auguste Renoir, among others. Moreau had encouraged his students to get out of the Louvre, so when Wéry asked Matisse to accompany him on a painting trip to the rugged channel province of Brittany in the summer of 1895, Matisse went, and returned again the following summer.

His seascapes and interiors of this time are filled with a cool gray light, a brightening—if not to color, at least to the letting in of light in a new way into his compositions. As Matisse recalled many years later: "The search for color did not come to me from studying paintings, but from the outside—that is from the revelation of light in nature." Impressionism introduced into Matisse's working habits the method of painting outside in the open air. Additionally, Wéry was able to acquaint Matisse with Impressionist techniques, and

introduce him to another Impressionist painter, the Australian John P. Russell, who knew Monet and gave Matisse two drawings by the Dutch artist Vincent van Gogh. This was Matisse's first exposure to nonacademic painting, and thereafter, his work changed.

In the fall of 1896, Moreau suggested that Matisse work on a large, important painting to exhibit in the spring—a sort of graduation piece to prove his artistic merits to the world. Matisse produced *The Dinner Table*, which he showed at the Salon de la Nationale. Although this painting was, perhaps predictably, disliked by the critics who saw it as a manifesto for the (then unpopular) Impressionist technique, it was also a testimony Matisse's personal assimilation of Impressionism, from which he was now ready to move on. Its theme of bourgeois comfort, the well-laid table complete with a gentle and docile female servant—was a well-chosen vehicle to show off multiple light-filled still lifes in Matisse's most complex and virtuoso composition to date.

MARRIAGE, FAMILY, AND ART

In a bid to hold onto domestic bliss, though one by no means as opulent as that pictured in *The Dinner Table*, Matisse, whose relationship with Caroline Joblaud had ended by the fall of 1897, found a new love. She was Amélie Noémie Alexandrine Parayre, a dark-haired beauty he described as a person of great "kindness, force and gentleness." Matisse met his future wife at a friend's wedding, and they were married soon after on January 8, 1898, at the mayor's office, followed by a religious ceremony. Their marriage, which lasted until their separation some forty years later, began with a brief honeymoon in London, followed by a more lengthy sojourn in Ajaccio in Corsica and

66 *We define genius as the capacity for productive reaction against one's training.* **99**

—BERNARD BERENSON

Male Model

c. 1900, oil on canvas;
39⅛ x 28⅝ in.
(99.3 x 72.7 cm).
Kay Sage Tanguy and
Abby Aldrich Rockefeller
Funds, The Museum of
Modern Art, New York.
Male nudes are rare
in Matisse's work—
the female nude was
his preferred subject.
This early study shows
Matisse's admiration
for the work of Paul
Cézanne—Matisse
has used Cézanne's
palette of dark blues
and greens, and
modeled the figure
with angular planes.

some time in Toulouse with his wife's family.

Madame Matisse was a tall, slender woman from near Toulouse in the south of France. Born on February 16, 1872, she was two years younger than her husband. She was to be of great assistance emotionally and financially to Matisse in the difficult years that followed their marriage, calming him during nocturnal attacks of anxiety and insomnia, and ultimately supporting their growing family in hard times by opening a millinery shop in Paris. The Matisse family grew quickly with the birth of their son Jean Gérard in January of 1899, followed by Pierre in June of 1900, but Matisse's resources could not keep pace with his family's needs.

The year 1898 was one of great change for Matisse—it brought not only his marriage, but also the death of his beloved teacher Moreau, and the end of his days as an art student. When working under the painter Fernand Cormon, he was asked to leave because he was over thirty, and yield his place to a younger student. He tried yet another studio, but after a year at the painter Eugène Carrière's studio, in which the master never spoke a word to him, it was clear his days as a student painter were over.

It was also at this time that Matisse became acquainted, through the recommendation of

the aged Impressionist painter Camille Pissarro, with the work of Paul Cézanne, the French painter from Aix-en-Provence who is now credited with the birth of modern painting. In 1899, Matisse, who could ill afford it, bought a small painting by Cézanne, *The Three Bathers*, from the art dealer Ambroise Vollard, as well as the *Head of a Boy* painted by Paul Gauguin and a plaster bust by the great sculptor Auguste Rodin. The Cézanne painting was to be critical to the development of Matisse's style. He loved the painting passionately and owned it for thirty-seven years before he presented it to the Petit Palais Museum in Paris, refusing to sell it in hard times and good. This painting, he wrote, "sustained me spiritually in the critical moments of my career as an artist." "Cézanne is the master of us all," Matisse declared, and it is from study of this one painting that he learned more than from all his academic lessons combined.

The structural quality of Cézanne's paintings, in particular, the sculptural quality of the three bathing nudes in the work Matisse had purchased, seems to have driven him back to the role of an inquiring art student, this time in the medium of sculpture. Matisse felt that sculpture helped him clarify the idea of structure in painting, a problem that Cézanne's

YOUTH, EDUCATION, AND EXPERIMENTS IN STYLE

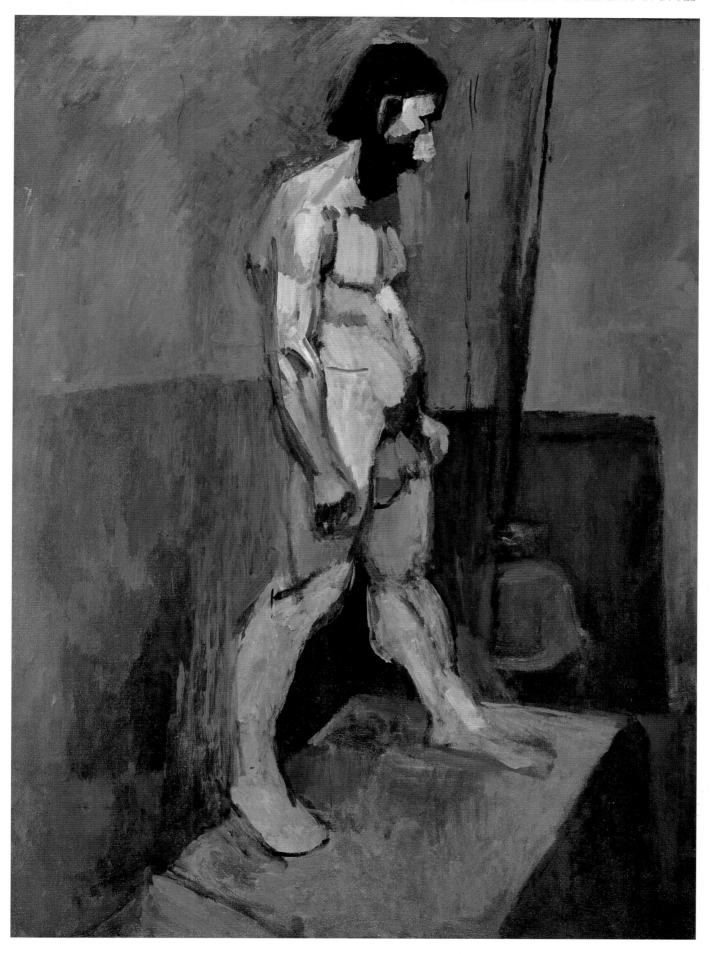

work clearly posed for him. Matisse began work on his first sculpture, a study after French nineteenth-century sculptor Antoine-Louis Barye's *Jaguar Devouring a Hare*, in the studio of Rodin's pupil Antoine Bourdelle. To truly understand the forms of the creatures he was depicting, he obtained the bodies of a rabbit and a cat (as a substitute for a jaguar) to dissect.

Matisse's first original sculpture, *The Serf*, was a rugged male nude in bronze, about half life size, on which he spent over five hundred sessions over the course of four years with a live model (a man called Bevilacqua, who also modeled for Rodin). Art historian John Elderfield has noted that in these remarkably numerous sittings Matisse "grew up" as an artist, the way Picasso did with the endless sittings the American writer and art collector Gertrude Stein sat through for his famous portrait of her. The close relationship between Matisse's painting and his sculpture in this period of growth can be seen by comparing the armless and thus psychologically powerless *Serf* sculpture with the painting *Male Model*, whose simplified faceted planes owe much to Cézanne's vision. Matisse's paintings of the next few years became notably more adventurous in their form because of his preoccupation with Cézanne and also brighter in color, in part from Cézanne's influence and in part, it appears, from his exposure to the

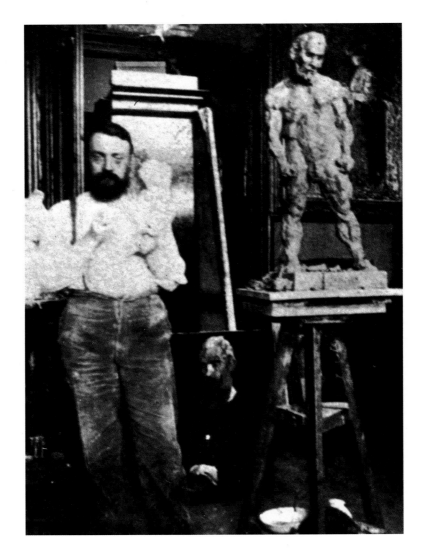

Matisse in His Studio with *The Serf*

c. 1902, photograph. The Museum of Modern Art, New York.

This photograph shows Matisse with his sculpture *The Serf*, in an early state, before the arms were removed. Matisse used an Italian model named Bevilacqua (who also posed for Rodin) for more than five hundred sittings before he was satisfied with the sculpture. The powerfully built forms of Bevilacqua's body gave Matisse inspiration for his sculptural theme of strength and perseverance.

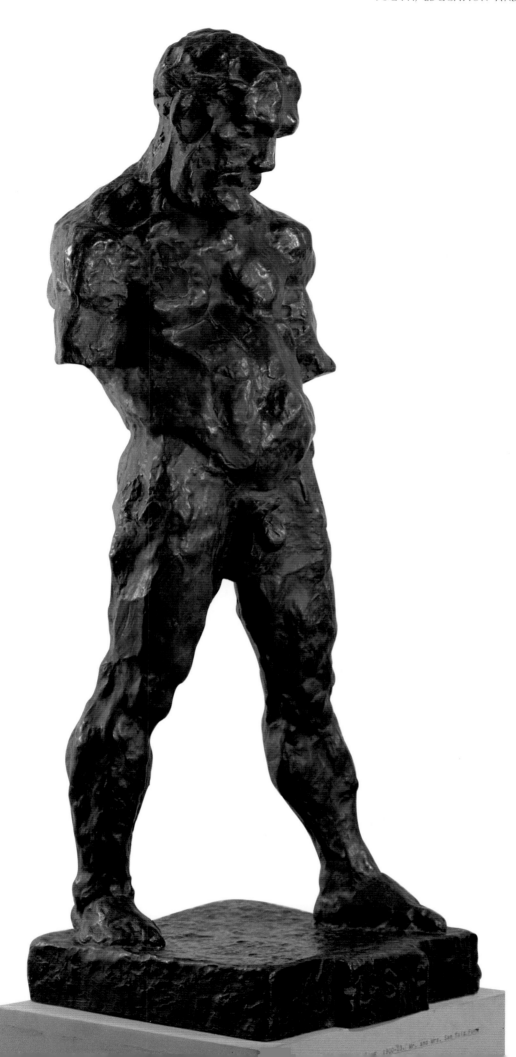

The Serf

1900–04, bronze;
37⅜ x 13⅜ x 13 in.
(92.3 x 34.5 x 33 cm).
Mr. and Mrs. Sam Salz
Fund, The Museum
of Modern Art, New York.
The same model posed
for *The Serf*, Matisse's
first original sculpture,
and his painting *Male
Model. The Serf* is also
a homage to Rodin's
famous headless and
armless *Walking Man*
(1877). Matisse began
to study sculpture
after he purchased
Cézanne's painting
The Three Bathers
in 1899, because he
was impressed by
the sculptural qualities
of Cézanne's figures.

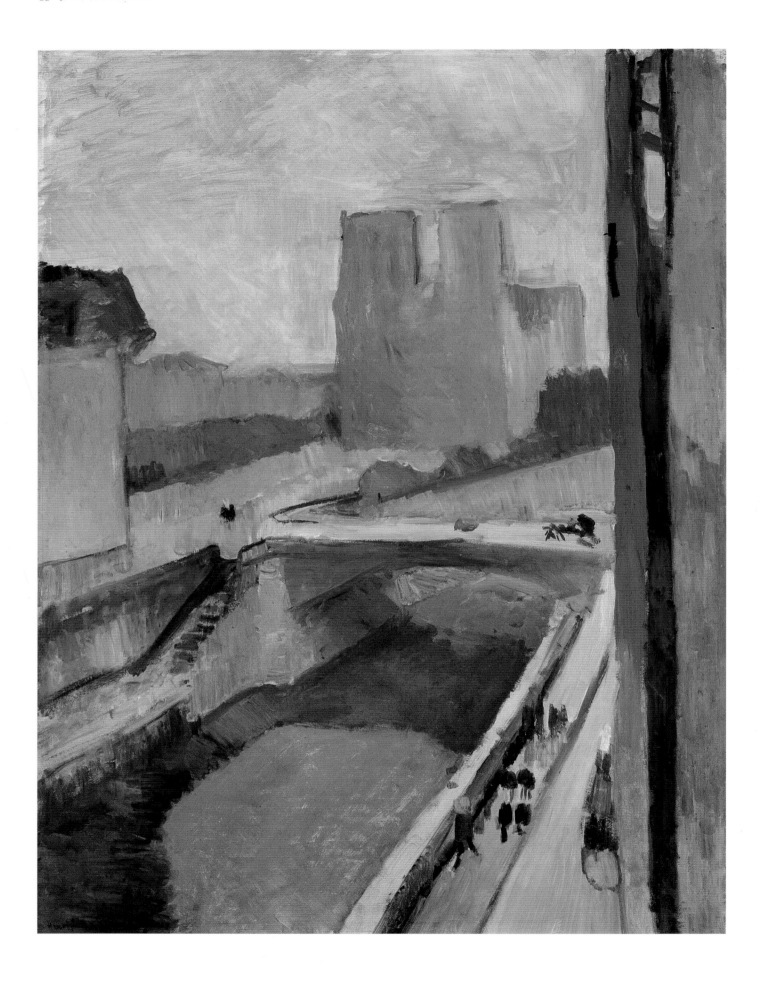

bright light of the south on his honeymoon travels to Corsica and Toulouse. The unfinished *Still Life with Oranges, II* (1899), *The Luxembourg Gardens* (1901–02), and *Notre-Dame in the Late Afternoon* (1902), as well as the landscapes studies from Corsica all give evidence that Matisse is beginning to release his naturally inspired sense of color from its academic bondage.

Even as new color brought brightness to his works of this period, Matisse's self-portraits of the year 1900 reveal some of the anxiety and stresses he was feeling as a newly

responsible husband and father of young children. Marguerite was deathly ill with diphtheria in 1901 and had to have a tracheotomy to save her life. (Thereafter she often wore a ribbon around her neck to conceal the scar, which can be seen in Matisse's portraits of her.) Madame Matisse, also feeling the strain, was worn out and anemic.

To make ends meet, Matisse, together with his friend Marquet, was driven to undertake odd jobs; they worked in a shop that decorated theatrical scenery, and also on the decorations—miles of gilded laurel leaves and

The Luxembourg Gardens

1901–02, oil on canvas; 23⅜ x 32 in. (59.5 x 81.5 cm). The Hermitage, St. Petersburg. This landscape of a popular Paris park shows the brightening colors of Matisse's "proto-fauve" period—the next few years would see a great change in his use of color, culminating in the violent, nondescriptive colors of his Fauve period. The broadly defined forms of the trees and expressive colors and shapes in this painting suggest Matisse's admiration for the work of Gauguin.

Notre-Dame in the Late Afternoon

1902, oil on paper mounted on canvas; 28 x 21 in. (72.5 x 54.5 cm). Gift of Seymour H. Knox, 1927, Albright-Knox Art Gallery, Buffalo. This view from Matisse's studio on the Quai Saint Michel—a view he was to paint many times—shows the square towers of the church of Notre-Dame and the Petit Pont, one of the many bridges across the Seine, with sketchily painted pedestrians and a horse-drawn carriage. Framed by the edge of the window, this study in blue and violet has generalized misty forms that are associated with Impressionism.

a giant panorama—for the Grand Palais, a large exhibition hall then under construction. Working in the damp and dusty half-finished building, Matisse contracted a case of bronchitis that would not be cured. His father, hoping to restore him to health, invited him for a trip of several weeks to the Swiss Alps, and indeed, the fresh mountain air did the trick. However, when Matisse returned to Paris, his father, having lost faith in the direction his art career had taken, cut off the allowance he had been providing. Matisse, desperate and without means, his wife's health also a cause of concern, was forced to bring his family back home to Bohain-en-Vermandois, where they remained for the winters of 1902 and 1903.

The paintings that Matisse continued to send to the Salon des Indépendants began to sell, however, and the dealer Berthe Weill sold one as well. Taking heart, the Matisses returned to Paris, keeping Marguerite with them, and sending Jean and Pierre to stay with grandparents and aunts. Madame Matisse opened a small milliner's shop, and her success selling hats provided the family with enough income to enable Matisse to keep painting. During these lean years, Amélie often served as a model for Matisse as well, posing, for the most part patiently, in Japanese robes, as a guitarist, and in the nude. Her strong features and dark, upswept hair are quite unmistakable. Marguerite was also a patient model, posing many times for her father, with whom she was very close. The boys also appear in paintings from time to time, but they had a more difficult time keeping still, although all the children were admonished to keep quiet at the dinner table, so as not to disturb their father.

Matisse had his first solo show at Ambroise Vollard's gallery in June of 1904—forty-five

Landscape of Villars-sur-Ollon, Switzerland

1901, oil on cardboard; 6¼ x 8½ in. (16 x 22 cm). Musée des Beaux-Arts, Bordeaux.

Shortly before Matisse's father cut off his allowance, he took Matisse on a trip to the Swiss Alps hoping to cure him of a bout with bronchitis. Matisse recalled "I only wanted to bring back from my very short stay some small paintings and simple images, I don't believe mountain landscapes can be of much use to painters."

> **66** *Henri Matisse delights in capturing anything that pleases his profound and lucid sight. He welcomes the sunbeam that kindles the brilliance of chrysanthemums and tulips in the half-shadows, or the bright reflections on the shimmering surface of a ceramic or of golden tableware.* **99**
>
> —ROGER MARX
> *EXHIBITION OF WORKS BY THE PAINTER HENRI MATISSE (1904)*

of his paintings and one drawing were displayed. Financially and critically, the show was not a success. However, in the catalogue preface, the critic Roger Marx praised Matisse's work in a way that spoke to the future: "Ever on the alert, Henri Matisse delights in capturing anything that pleases his profound and lucid sight."

NEO-IMPRESSIONISM AND FAUVISM

Friendships with other artists were always an important part of Matisse's life. He benefited immeasurably from the sharing of ideas and influences they provided, and perhaps at no time in his life was this more true than in the years 1904 and 1905. Matisse's friendships with the painters André Derain and Maurice de Vlaminck were to change the course of

modern art at the beginning of the twentieth century. Together, they developed a style now known as Fauvism, which vibrated with bold jarring colors and brushstrokes.

The beginning of Matisse's transition to bright unrealistic color began in the summer of 1904. He left Paris with his family to spend the summer in Saint-Tropez in the south of France near the Neo-Impressionist painter Paul Signac, whom he had met earlier in the year. Matisse's delight in the warm light of the south shines through in his painting *The Terrace, Saint-Tropez*. Framed with green fronds and awash in sunlight and bright shadow, the scene has the feeling of a breath of fresh air from an open window. In fact, the window was to become a favored theme throughout Matisse's life, and one he was to paint in *The Open Window*, with a rush of

Luxe, calme et volupté

1904–05, oil on canvas;
33⅞ x 45⅝ in. (86 x 116 cm).
Musée National d'Art Moderne,
Centre Georges Pompidou, Paris.
This canvas is Matisse's grand
experiment with the tech-
nique of Pointillism. The
dotted brushstrokes represent
his application of a scientific
color theory in which the
eye is supposed to blend bright
dots of contrasting color
placed side by side. The subject
is a fantasy of nude bathers
combined with a portrait
of Madame Matisse (the only
clothed figure) and her son
(who is wrapped in a towel)
having a picnic at the shore.

even brighter color the following summer in the Mediterranean town of Collioure.

The summer of 1904 in Saint-Tropez was one of great stylistic exploration for Matisse. His works from this period range from Cézannian still lifes to Gauguinesque land-scapes, then focus on the Neo-Impressionist style and theory of the painter Georges Seu-rat, as interpreted by his friend Paul Signac. This color theory, know as Divisionism or Pointillism, was a fairly rigid system of creat-ing an image on canvas with small dots of pure color. Complimentary colors such as red and green were placed side by side, for ex-ample, so that the eye could mix them from a distance. Pointillism worked well for Seurat, but no other artist was ever able to make a complete success of it.

Matisse gave the theory of Pointillism his best shot in *Luxe, calme et volupté*, a painting notable for its dotted brushwork as well as its

brilliant color. (Matisse found the tedious broken brushwork of Divisionism too re-strictive, and after giving it a try, he was quick to move on.) This painting, which was one of thirteen canvases Matisse sent for exhibition to the Autumn Salon in 1904, was promptly bought by Signac, and not displayed again in public for many years.

The subject of *Luxe, calme et volupté* (the title translates roughly as "luxury, tranquillity and sensual pleasure") has been much dis-cussed and analyzed in the history of art. It is a curious amalgam of visions; a group of voluptuous nude female bathers share the shimmering shoreline with the dressed and hatted figure of Madame Matisse, the towel-wrapped little body of son Pierre, and the remains of their picnic, neatly laid out on the ground complete with teacups and saucers. This collision of two worlds, the highly personal domestic scene and a male erotic fantasy (one of long-standing tra-dition in Western art) are brought together with stiff little brush-strokes and a rainbow of brilliant colors. This is the beginning of Matisse's true release of his imagi-nation—a break with comfortable and familiar subject matter.

The name of the painting is drawn from the refrain of a poem called *L'Invitation au voyage* ("invita-tion to travel") by Charles Bau-delaire. The refrain, and the title of Matisse's painting, describe the qualities of the place traveled to—whether that place is real, imaginary or metaphorical is not clear in the poem. Here Matisse finally allows himself to start expressing his own vision of the "paradise" which, he said, the act

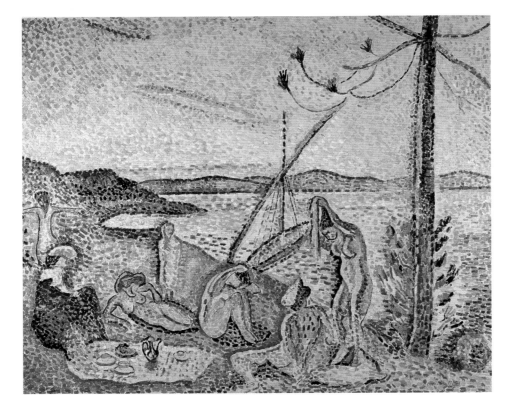

**The Terrace,
Saint-Tropez**

*1904, oil on canvas;
28¼ x 22¾ in.
(72 x 58 cm). Gift of
Thomas Whittemore,
Isabella Stewart Gardner
Museum, Boston.*
This painting records
the summer the
Matisses spent in the
South of France with
the Neo-Impressionist
painter Paul Signac.
The building is
actually the side of
Signac's boathouse,
with Madame Matisse
posing in a Japanese
kimono in the
building's shadow.

of painting gave to him from the very first time he picked up a paintbrush. Baudelaire's poem describes a sensual paradise that also becomes, in a sense, Matisse's personal theme of paradise in many future paintings.

ARBITRARY COLOR

The summer of 1905 found the thirty-five-year-old Matisse back on the coast of the Mediterranean, this time in the small seaport of Collioure near the Spanish border where he was working alongside his friend André Derain. The paintings Matisse completed that

summer and the following fall were unlike any he had done before. A chance visit to Daniel de Monfreid, a painter in the area who owned a number of Tahitian canvases by Paul Gauguin, appears to have inspired Matisse's move into arbitrary color—that is, color that he felt was right in feeling for the paintings rather than colors he actually saw.

While arbitrary color does not seem like a radical idea now, at the end of the twentieth century, when such freedoms of expression are taken for granted, at the beginning of the century it was highly unusual. Matisse began

The Roof at Collioure

1905, oil on canvas;
23⅜ x 28¾ in. (59.5 x 73 cm).
The Hermitage, St. Petersburg.
The bright colors and
bold brushstrokes in this
view of a small fishing
town on the Mediter-
ranean signal that Matisse
has moved into his "fauve"
period. For the next
few years the unconven-
tional paintings of Matisse
and his fellow "fauves"
André Derain, Maurice
de Vlaminck, and others
would provoke the
wrath of French critics,
who considered the
new style disturbing,
violent, and outrageous.

using vividly contrasting colors such as reds and greens slashed across his canvases in broad brushstrokes in an expressionistic manner, rather than placing points of contrasting color side by side in the controlled dots of Pointillism as he had during the previous summer. This new technique resulted in such memorable pictures as *The Roof at Collioure, Portrait of Madame Matisse/The Green Line,* and *Woman with a Hat.*

In *Notes of a Painter,* Matisse explains his use of color thus: "My choice of colors does not rest on any scientific theory; it is based on observation, on sensitivity, on felt experiences." He notes that the "chief function of color should be to serve expression as well as possible." For example, he writes, to "paint an autumn landscape I will not try to remember what colors suit this season, I will be inspired only by the sensation that the season arouses in me."

LES FAUVES

Matisse was not alone in his new approach to color, but he was the leader in a group of painters that included many friends and con-temporaries also experimenting in a similar fashion at this time—André Derain, Maurice de Vlaminck, Charles Camoin, Henri Manguin, Georges Rouault, and Albert Mar-quet, among others. Their work was all hung in the same room at the 1905 Autumn Salon, where its brightness and newness provoked the wrath of the public and critics alike. The critic Louis Vauxcelles gave the artists of this new movement a name—*les fauves* ("the wild beasts"). When entering the room he noted a small bust, which resembled the work of an Italian Renaissance sculptor, surrounded by walls filled with bright, unusual paintings and remarked "Well, Donatello among the wild beasts!" Matisse and his fellow "fauves" also

continued to make a statement by showing their work together in the month following the Salon at Berthe Weill's gallery.

The paintings of the Fauves—or Fauvism, as the art movement is now called—are widely considered to represent, in the words of art historian George Heard Hamilton, "the first incontestably modern movement of the twentieth century." The artists of the move-ment never used the (at that time derogatory) name "fauve" themselves. And as is clear from Matisse's sensitive and perceptive statements in *Notes of a Painter,* the name "fauve" was not at all expressive of the group's goal or tem-perament. Matisse, the leader of the move-ment, was a sober, hard-working individual, and devoted family man—an image he sought to clarify to the press whenever he had the opportunity.

Matisse went only once to the opening of the exhibition that included his *Woman with a Hat,* to hear what people were saying. He did not return. However, he soon received an offer of four hundred francs for the painting, which he refused on the advice of his wife, holding out for the full asking price of five hundred francs. This he received and the sale was completed. Soon it was mutually arranged that he and his wife meet the buyers, the American sister and brother Gertrude and Leo Stein. Actually, it was Gertrude who had been attracted to the painting and determined to own it. Leo con-sidered it "a thing brilliant and powerful but the nastiest smear of paint I had ever seen"—although he soon reconsidered this opinion once he had gotten over "the unpleasantness of the putting on of the paint."

Gertrude and Leo Stein were to become Matisse's first important patrons and champi-ons, and also, for a while, significant friends. Gertrude Stein, herself an innovator in the

field of writing, recorded her many insights and impressions of Matisse in *The Autobiography of Alice B. Toklas*, a tongue-in-cheek autobiography of her life in Paris during this period presented as a narration by her conversational lifelong companion Alice B. Toklas.

Stein described the Autumn Salon of 1905 as having a great deal of freshness: "There were a number of attractive pictures but there was also one that was not attractive. It infuriated the public, they tried to scratch off the paint . . . Gertrude Stein liked that picture, it was a portrait of a woman with a long face and a fan. It was very strange in its color and in its anatomy." The painting, a portrait of Madame Matisse (who had sat in her usual black dress and an enormous hat—not in a costume of the bright colors Matisse actually painted), is actually modeled on a totally conventional standard of portraiture. It is the manner in which it is painted that startled, enraged, and amused the public at that time—and made it one of the most famous paintings of the century.

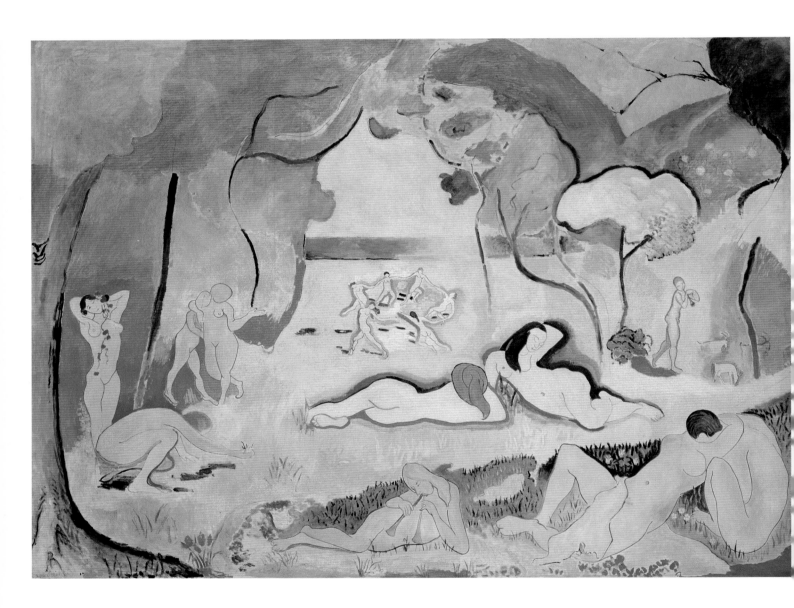

The Joy of Life

1905–06, oil on canvas; 69⅛ x 94⅞ (175 x 241 cm).

The Barnes Foundation, Merion, Pennsylvania.

Matisse achieved a stylistic breakthrough in this brilliantly colored painting showing an earthly paradise peopled with nudes absorbed in love, dance, music, and nature. This painting was originally purchased by Matisse's patrons Gertrude and Leo Stein, who displayed it in their Paris apartment.

Chapter Two

BREAKTHROUGH, PATRONS, TEACHING, AND TRAVEL

In the fall of 1905, Matisse began working on *The Joy of Life*, a painting that was, for him, a significant departure in both subject and style. Instead of being painted from life, it was painted from imagination, something that Matisse had attempted only once before, in *Luxe, calme et volupté*. Instead of being painted in varied, well defined brushstrokes, the paint was applied in broad flat areas, with simple outlines used to define forms. The result was a monumental canvas, bright with a rainbow of "fauve" colors that created a landscape tapestry verging on the abstract. The landscape of trees and grass presents, like a stage set, an idyllic scene of earthly delights where nude figures indulge in various pleasures and pastimes from music and dance to loving and lounging.

THE JOY OF LIFE

Matisse was well aware of the importance of this new work—he sent it as his only contribution to the Autumn Salon of 1906. The critics met his offering with perhaps

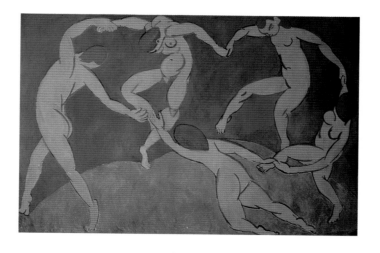

predictable indignation and the public with incomprehension and derision. One of his sternest critics was his former mentor, Paul Signac, who remarked that Matisse's painting had "gone to the dogs."

Leo Stein was puzzled when he first saw the painting, and went back to study it many times over the course of a week, before he

decided to buy it—but he later said that he felt it was the most important painting of the time. *The Joy of Life* thus came to hang in a place of honor in the Steins' Paris apartment, where the young Spanish painter Pablo Picasso saw it. A little later, Picasso painted his own critical response to Matisse, the famous *Les Demoiselles d'Avignon* of 1907. Picasso's

Dance (II)

1909–10, oil on canvas; 8 ft. 5⅝ in. x 12 ft. 9 in. (260 x 391 cm). The Hermitage Museum, St. Petersburg. This monumental panel was painted on commission for Matisse's wealthy patron Sergei Shchukin. The violence and frenzy of this dance is suggested by the bright red of the figures as well as their energetic postures, which have been heightened since Matisse's earlier study, *Dance (I)*.

painting seems to imply, according to art historian Jack Flam, that Matisse had gone, not too far, as everyone else seemed to feel, but not far enough!

The significance of *The Joy of Life* for Matisse's own future painting was the way he established a decorative, lyrical linear style and idyllic joyful themes that were to sustain his work in this direction and provide inspiration for the future. Themes such as the circling dancers in the background of *The Joy of Life* were to reappear in his monumental mural decorations, and other paintings as well. Ultimately, it was freedom of imagination that Matisse let loose in this work, which was as significant to the future of his painting as the liberation of his color.

EXCITING TIMES

The year 1906 was a significant one for Matisse; he met Pablo Picasso and Georges Braque, bought his first African sculpture, made his first lithographs, traveled to North Africa, had his first show outside of France (at La Libre Esthétique in Brussels), had his second large one-artist exhibition at the Druet Gallery in Paris (which included fifty-five paintings, three sculptures, watercolors, and drawings, as well as his first lithographs and woodcuts), and met important new patrons. All these events were to have a strong impact on his life and work.

Pablo Picasso and Georges Braque were two young innovative painters who were soon to develop Cubism, a "third dimension" of painting that had an incomparable impact on the way future painters would approach structure and space. The meeting of Picasso and Matisse was arranged by Gertrude Stein with ease at her home. Gertrude Stein was already a patron and admirer of the twenty-five-year-old genius Picasso, and was by this time also seeing the Matisses socially. Matisse, who was twelve years Picasso's senior, was clearly the star at this first meeting. He was self-assured, and did most of the talking. But in the future the two artists, according to art historian John Russell, "were never rivals in the commonplace sense, but neither were they close friends. Each recognized the other as a supreme professional."

Their introduction also began a period of rivalry for Gertrude Stein's attention and patronage, in which Picasso eventually won out. Both artists learned from each other's work however—and stayed in communication for a lifetime. Matisse later went through a somber period of painting that brought some of the analysis of Cubism, if not its style, into his work.

Matisse also most probably introduced Picasso to African sculpture, which he was beginning to collect and greatly admired. The bold simplifications of these carved wood figures, and masklike faces had significance in his own search for simplification. And the forms of African art immediately made themselves felt in Picasso's work, too, beginning with *Les Demoiselles d'Avignon*. Although quite different in both artistic style and personality, Matisse and Picasso were two of the most influential driving forces in the history of modern art.

Knowing the Steins changed Matisse's fortunes as a painter and raised his value in the eyes of the world, as he began to increasingly win patrons outside of the narrow critical circle in France. Gertrude and Leo's older brother, Michael Stein, and his wife, Sarah, also became enthusiastic collectors and supporters of Matisse. It was through them that Matisse was introduced to a number of other American collectors, such as Claribel and Etta Cone

Music

1907, oil and charcoal on canvas; 29 x 24 in. (73.4 x 60.8 cm). Gift of A. Conger Goodyear in honor of Alfred H. Barr, Jr., The Museum of Modern Art, New York. Matisse has left bright "fauve" color behind in this important work, which anticipates the style of *Music* and *Dance*, the decorations Matisse would soon be commissioned to paint by his Russian patron Sergei Shchukin. Music was an important part of Matisse's life and musical themes make a regular appearance in his paintings.

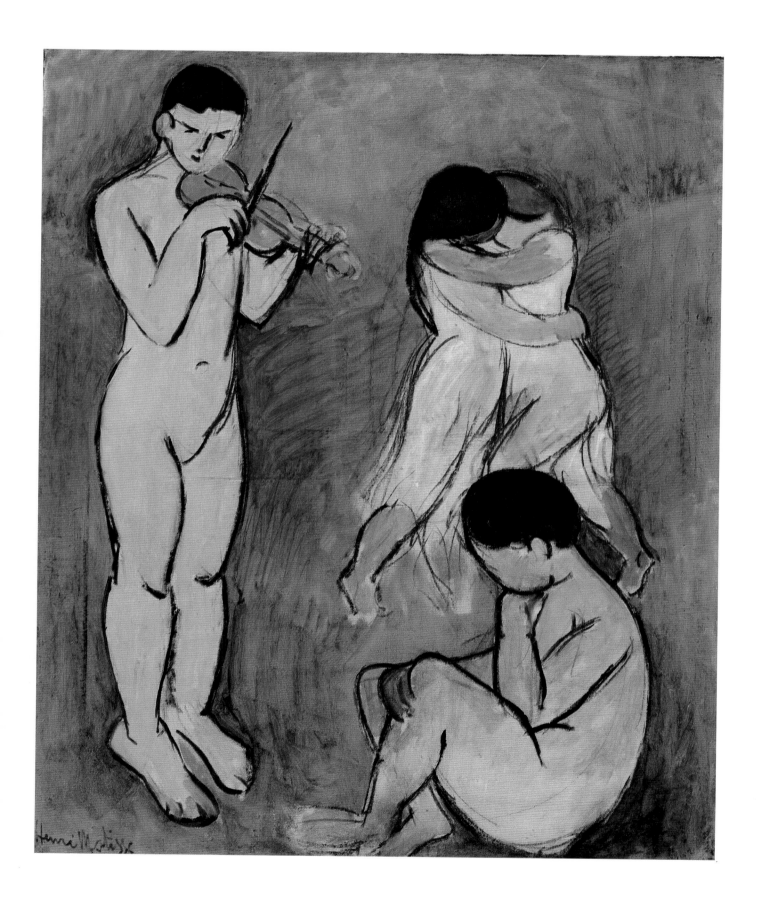

66 What interests me most is neither still life nor landscape, but the human figure. It is that which best permits me to express my almost religious awe towards life. 99

—HENRI MATISSE
NOTES OF A PAINTER (1908)

**Blue Nude
(Memory
of Biskra)**

*1907, oil on canvas;
36¼ x 55¼ in.
(92.1 x 140.4 cm).
The Cone Collection,
The Baltimore Museum of Art.*
This energetically
modeled nude was
inspired by Matisse's
own sculpture, *Reclining
Nude, I,* as well as by
memories of the oasis
at Biskra which he
saw on his first trip to
Algeria. The painting
was shown at the 1913
Armory Show in New
York, and then traveled
to Chicago where it
was burned in effigy by
outraged art students.

of Baltimore and Harriet Levy of San Francisco. In 1906 Matisse met the Russian collector Sergei Shchukin, who was within a short time to become one of his most important collectors.

During the winter of 1905–06, Matisse had gone to Algeria, where he was deeply impressed by the light, sights, and culture. As a result of this trip, he painted his next memorable and controversial work, *Blue Nude: Memory of Biskra,* which he showed at the Salon des Indépendants of 1907 to great furor. Again, it was not the subject in itself that was controversial—for nudes were a staple of Salon painting—it was the manner in which the female nude was painted.

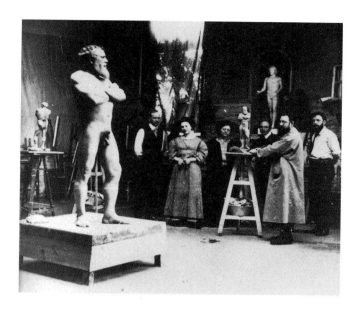

Matisse's new style was raw with power and energy, and energy was integral in the lines and volumes of the *Blue Nude*, the form of which may have derived, in part, from the forms of African sculpture. In the summer of 1906, Matisse returned to Collioure to paint and produced, among other works, two versions of *The Young Sailor*, which are notable for their powerful distillations and simplification of form and their decorative elegance. The Matisses also traveled to Italy in 1907, where Matisse was particularly interested in the work of the great Italian artists Duccio, Giotto, and Piero della Francesca. Although Matisse had not initially been enthusiastic about the trip, he ended up finding much to admire, and for Madame Matisse, the trip was the fulfillment of a childhood dream.

The period of 1908 to 1910 was one of growing international interest in Matisse's work. His first show in the United States was in 1908: an exhibition of his graphic art and watercolors at the 291 Gallery in New York, arranged by the young American photographer and painter Edward Steichen (whom Matisse met through Sarah Stein). This was followed by a second show at 291 in 1910. Matisse also had an important retrospective exhibit at the Autumn Salon in Paris, where he showed a number of paintings, drawings, and sculptures.

In 1908, he also took the first of several trips to Germany, culminating with a show in Berlin. Matisse's ideas were greatly furthered by his lucid and articulate statement on art, *Notes of a Painter*, which was published in *La Grande Revue*, and soon translated into German and Russian. *Notes of a Painter* contained Matisse's famous statement of his philosophy of art, which was widely repeated, and sometimes used against him—when critics wished to deride his art as decorative, easy, or comfortable:

> What I dream of is an art of balance, of purity and serenity, devoid of troubling or depressing subject matter, an art which could be for every mental worker, for the businessman as well as the man of letters, for example, a soothing, calming influence on the mind, something like a good armchair which provides relaxation from physical fatigue.

In the future, Matisse would repeat this statement, but omit the reference to the "good armchair" that had brought him so much grief. It is also ironic that he expressed a wish that his art be "soothing" at the moment when he was being attacked as a "wild beast" of a painter—and his work was provoking violent reactions. A few years later, for example, Matisse's *Blue Nude* still caused such outrage that it was burned in effigy by art students in Chicago.

Sculpture Class at the Académie Matisse

c. 1909, photograph. Gift of Hans Purrmann and Alfred H. Barr, Jr., The Museum of Modern Art, New York. From 1908 to 1911 Matisse taught art at his own school which he had been persuaded to open by his good friend and patron Sarah Stein. The program was traditional and emphasized drawing and painting from plaster casts, the model, and still life, as well as the sculpture class seen here.

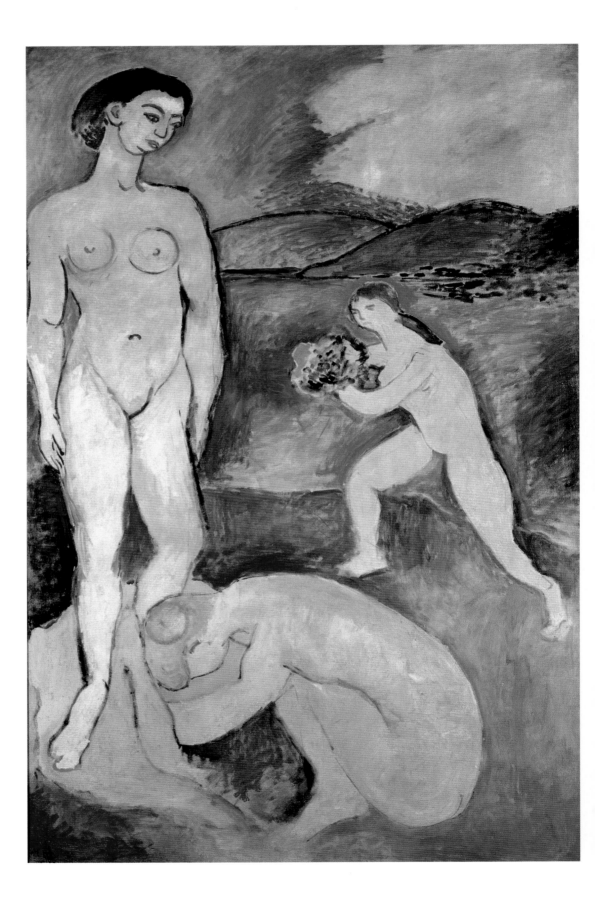

Le Luxe, I

1907, oil on canvas;
82¾ x 54⅜ in.
(210 x 138 cm).
Musée d'Art Moderne, Paris.
Luxury and ease are
personified by the
dark-haired nude
whose clothes lie
at her feet. While a
crouching woman
attends to her, another
woman leaps forward,
holding a bouquet
of flowers. The colors
are indecisive, neither
bright nor dull. The
somewhat unresolved
poses of the figures
are strengthened in
a slightly later version
of the painting,
Le Luxe, II, as are the
colors and outlines.

THE MATISSE SCHOOL

Having but recently been a student himself, Matisse was now encouraged by his friend and patron Sarah Stein to open an art school. He agreed, and Sarah Stein, together with his young German admirer Hans Purrmann and an American painter, Patrick Henry Bruce, set up the Matisse school in a former convent. The school endured from 1908 until 1911, attracting students of various degrees of talent and poverty—mostly from the United States, Central Europe, and Scandinavia. One young Hungarian student wanted to earn his living modeling for his own class (of mixed men and women) but some students thought this would be inappropriate—and too close for comfort. Other students, clearly half-starved, were found eating the pieces of bread left on easels for the purpose of erasing drawings.

The program of the art school was traditional, emphasizing drawing and painting from plaster casts, the model, the still life, and modeling in clay. Matisse gave criticism to the students every Saturday and insisted that the students adhere to nature, admonishing them "you must be able to walk firmly on the ground before you start walking a tightrope." Some students had come expecting a more radical approach to teaching from the "king of fauves," and others were so timid they caused Matisse to comment: "After each criticism I found myself faced with lambs, and I had to build them up constantly, every week, to make them into lions." Matisse found, after a few years, that he was wondering whether he was a painter or a teacher. The school demanded too much of his energy so he decided to close it.

Sarah Stein, who was also a student at the school she helped organize, kept careful notes on Matisse's teaching, which provide insight into Matisse's working methods. When speaking of the study of the model, for example, Matisse revealed his view of the human figure: "Remember that the foot is a bridge . . . arms are like roles of clay . . . this pelvis fits into the thighs and suggests an amphora . . . fit your parts into one another and build up your figure as a carpenter does a house."

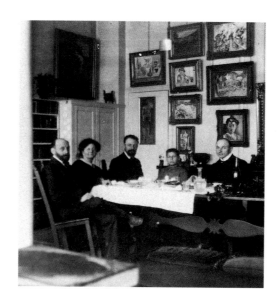

DOMESTIC THEMES

In the years he was teaching, Matisse continued to grow as an artist and rapidly produced one memorable and important work after another. In his two versions of *Le Luxe*, for example, he continues on the path of simplified lines and figures, and broad flat areas of color. *Harmony in Red* (1908) is the recreation

The Apartment of Michael and Sarah Stein at No. 58, Rue Madame, Paris

c. 1907, photograph. The Cone Archives, Baltimore Museum of Art. Matisse sits at table with a group of his friends and admirers while the wall behind is adorned with Matisse paintings in the Stein's collection, including the infamous Fauve *Portrait of Mme Matisse/ The Green Line* of 1905. Seated left to right are Michael and Sarah Stein, Matisse, Allan Stein, and Hans Purrmann.

into a new form of a by now old and famil-
iar subject in Matisse's work, the dinner table
with servant. The painting underwent several
major color changes, from *Harmony in Green*
to *Harmony in Blue*, to its final metamor-
phosis as *Harmony in Red*. As *Harmony in Blue*,

it was sold to Shchukin, but the artist then
repainted it before delivery.

Perspective is the most obvious omission in
this painting. The whole surface becomes flat
and decorative by having the red of the table-
cloth merge into the identically patterned red

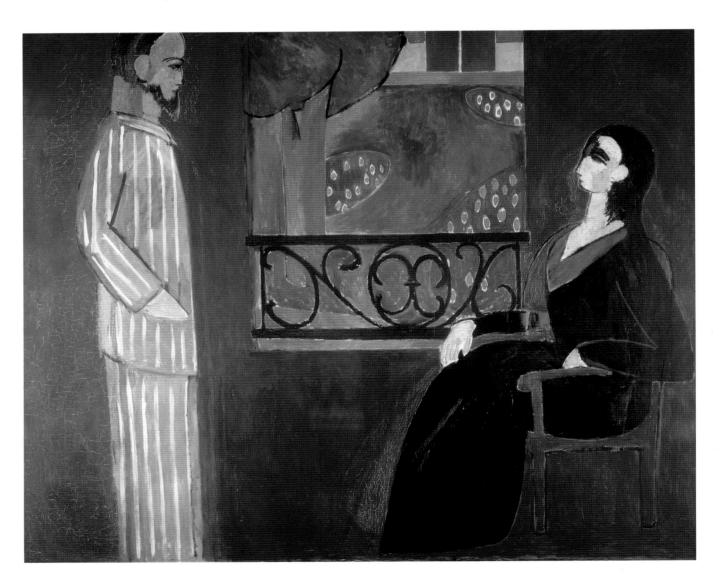

The Conversation

1908–12, oil on canvas; 69⅝ in. x 7 ft. 1⅜ in. (177 x 217 cm). The Hermitage Museum, St. Petersburg.

An unusual painting in Matisse's oeuvre, this canvas shows the artist and his wife in a domestic
confrontation. Matisse stands stiffly in blue-and-white striped pajamas while Madame Matisse sits facing
him in a black robe. Between them, the window opens up to a scene of grass, flowerbeds, and a tree.

of the wall behind it. Objects seem to dance across the surface—the only depth is provided, in a fashion, by the view of grass, sky, and trees in bloom seen through a window whose sill is more like a picture frame than that of a window.

On a more personal note *The Conversation* (also purchased by Shchukin), shows Matisse and his wife confronting each other in what is generally considered to be an argument. Matisse stands dressed in blue-and-white-striped pajamas while Amélie is seated in a

Harmony in Red

1908, oil on canvas; 70⅞ in. x 7 ft. 2⅝ in. (180 x 220 cm). The Hermitage Museum, St. Petersburg.

The bright red foreground and background flatten the space in this view of a table being cleared after dinner. The floral pattern of the tablecloth continues onto the wallpaper, and has equal importance with the figure, the objects on the table, and the view out the window. Originally the dominant color in the painting was mostly green, then blue, and finally red, as Matisse went through successive stages of repainting.

66 *This young painter—yet another dissident from the Moreau studio who has risen freely toward the summits of Cézanne—is assuming, willingly or not, the position of leader of a school.* 99

—LOUIS VAUXCELLES, GIL BLAS
"THE SALON DES INDÉPENDANTS" (MARCH 23, 1905)

black robe. The rigid figure of Matisse and the erect posture of his wife creates a tension between them verging on hostility. They are separated by the curves of a wrought-iron balcony and a simple landscape viewed out of a window. The painting is unusual because of the confrontation between the figures, something almost never seen in Matisse's work. For even when he depicts himself in a composition, as he sometimes did when painting from a model, his interaction with the model is usually diffused, rather than intense.

Thanks in a great part to the generous patronage of Shchukin, the wealthy merchant from Moscow who came to Paris frequently to indulge his passion for modern art, the Matisses' circumstances became increasingly comfortable during the years from 1908 to 1910. They were able to buy a house and land at Issy-les-Moulineaux, just outside of Paris, which had a garden, a greenhouse, and a large prefabricated studio shed that Matisse purchased in order to have room to paint the large decorations Shchukin had commissioned for his palatial home in Moscow.

According to Gertrude Stein, the Matisses were very comfortable in their new home and "soon the enormous studio was filled with enormous statues and enormous pictures. It was that period of Matisse." They also acquired a large black police dog, presented to them by Matisse's devoted German pupils.

In *The Red Studio* (1911), Matisse gives us a glimpse into his own working space, and we see it is filled with his creations, *Le Luxe* and *The Young Sailor* hang on the walls, while his

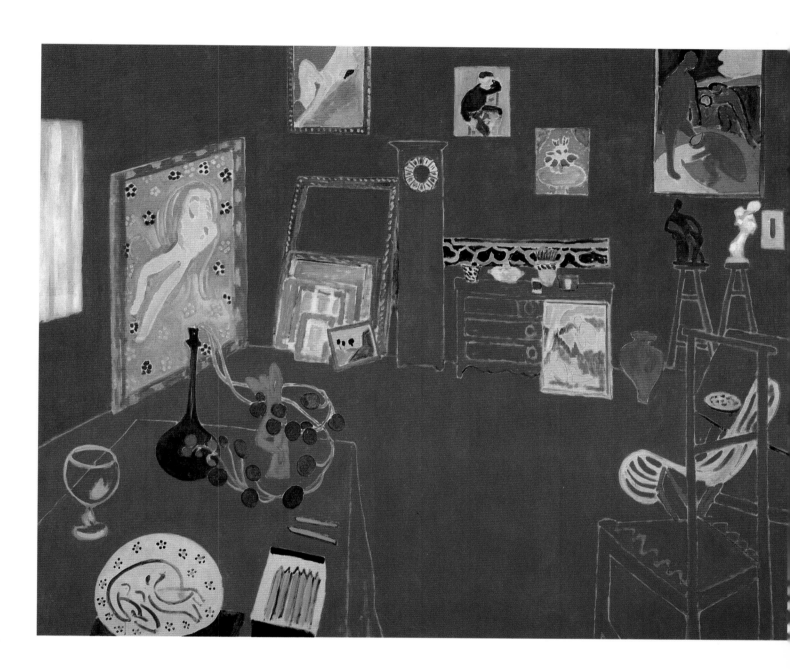

The Red Studio

1911, oil on canvas; 71¼ in. x 7 ft. 2¼ in. (181 x 219.1 cm).

Mrs. Simon Guggenheim Fund, The Museum of Modern Art, New York.

This view of the artist's studio (which in reality did not have
red walls or a red floor) presents a gallery of his recent works,
from familiar canvases and sculptures such as *Le Luxe* and
La Serpentine to a ceramic plate decorated with one of the
artist's designs. In the center of the room stands a grandfather
clock, which serves to remind the viewer of the passage of time.

❝ *Pay no attention to what the critics say; no statue has even been put up to a critic.* **❞**

—JEAN SIBELIUS

Matisse with
La Serpentine

Edward Steichen; 1909, platinum print; 11 ¹¹⁄₁₆ x 9¼ in. (29.6 x 23.4 cm). Gift of the photographer, The Museum of Modern Art, New York. American photographer Edward Steichen sensitively captured Matisse creating his famous sinuous sculpture, *La Serpentine*. Matisse wrote that he used as a model "a photograph of a woman, a little fat but very harmonious in form and movement."

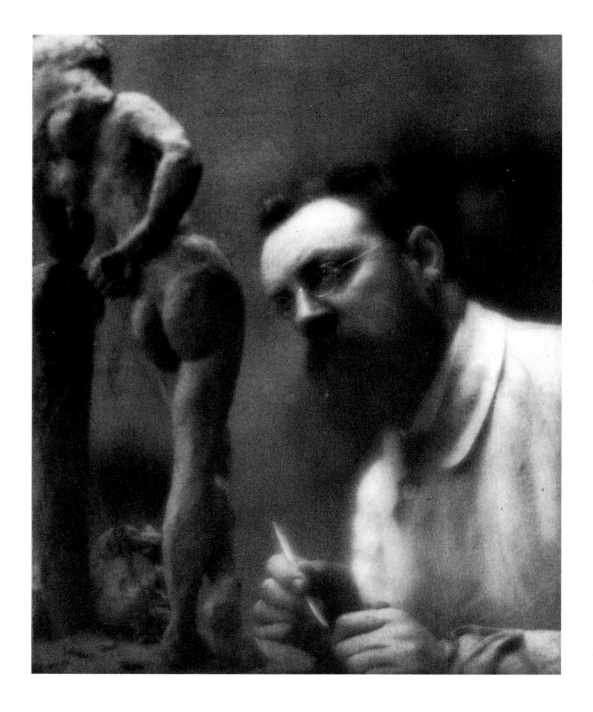

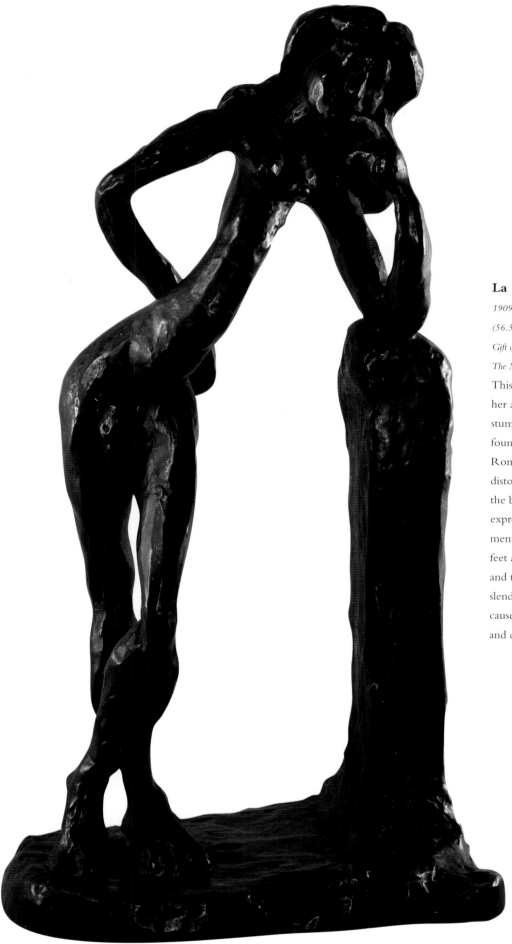

La Serpentine

1909, bronze; 22¼ x 11 x 7 in.
(56.5 x 28 x 19 cm).
Gift of Abby Aldrich Rockefeller,
The Museum of Modern Art, New York.
This female nude leans with
her arm supported by a tree
stump in a pose traditionally
found in ancient Greek and
Roman sculpture. Matisse
distorted the proportions of
the body intentionally to
express a harmony of move-
ment, so that the calves and
feet are heavy, while the thighs
and torso have a snakelike
slenderness. This sculpture
caused widespread outrage
and criticism when first shown.

66 *I hate that aesthetic game of the eye and the mind, played by these connoisseurs, these mandarins who 'appreciate' beauty.* **99**

—*PABLO PICASSO*

curvy nude bronze sculpture *La Serpentine*, a box of drawing materials, a ceramic plate also decorated by Matisse, and many other artworks are arrayed around a studio space that seems to dematerialize from the uniform red color of the floor, walls, and furniture.

A domestic view of the Matisse's new home is presented in *The Painter's Family*. The whole family is grouped around the fireplace. Pierre and Jean are playing checkers, Marguerite stands holding a book, and Madame Matisse sits sewing. The comfortable room overflows with pattern that fills almost every available space, including an oriental carpet, flowered wallpaper, and upholstered seats. Two bouquets and a cast of *The Serf*, a sculpture by Matisse, adorn the mantle.

NEW PATRONS

Matisse found two important Russian collectors in Sergei Shchukin and Ivan Morosov. By 1913, Shchukin had bought thirty-six Matisse works and Morosov had purchased eleven. Their patronage replaced that of Leo and Gertrude Stein, which had by then begun to dwindle. Shchukin commissioned two giant canvases, *Music* and *Dance*, to decorate the landing of the stairway in his grand home in Moscow.

Dance shows a circle of dancers (a motif drawn from *The Joy of Life*) which derives its energy and vibrancy from the active postures of the strongly outlined nude dancers. The dancers are painted in red while the sky is azure blue and the hill they dance upon is green. Matisse followed a scheme in planning the compositions whereby the first level of the staircase was to impart a feeling of energy and lightness with the dancers joined in whirling motion.

Music depicts engrossed participants with quieter but still active energy. A standing violinist, seated figures of a panpipe player, and three singers are painted in the same colors as the *Dance*. The decoration for the third level of the staircase, which was never painted, was to have shown people in calm repose.

When Shchukin saw *Music* and *Dance*, he would not at first accept the paintings. He said displaying such revealing nudes in the public areas of his home would bring disgrace on his family and they would loose their place in polite society, but he may also have been unnerved by the negative criticism the paintings had drawn in both France and Russia. He asked Matisse to add a little extra paint in the right places to some of the male figures, and this slight censorship solved the problem. Shchukin accepted the paintings and they were hung as planned.

These busy years were also marked by the death of Matisse's beloved idol Cézanne in 1906, and of Matisse's own father in 1910. The latter event, as well as Shchukin's initial rejection of *Music* and *Dance*, precipitated Matisse on a trip to Spain where he visited Seville, Granada, and Córdoba. Matisse also spent time in Moscow as Shchukin's guest. Additionally, he signed his first gallery contract in Paris with the Bernheim-Jeune Gallery, in which the gallery agreed to buy all his work at favorable prices based on size. And to feed the fire of inspiration, he saw two significant exhibitions of non-Western art, a show of Islamic art in Berlin and an exhibition of Persian miniatures at the Museum of Decorative Arts in Paris.

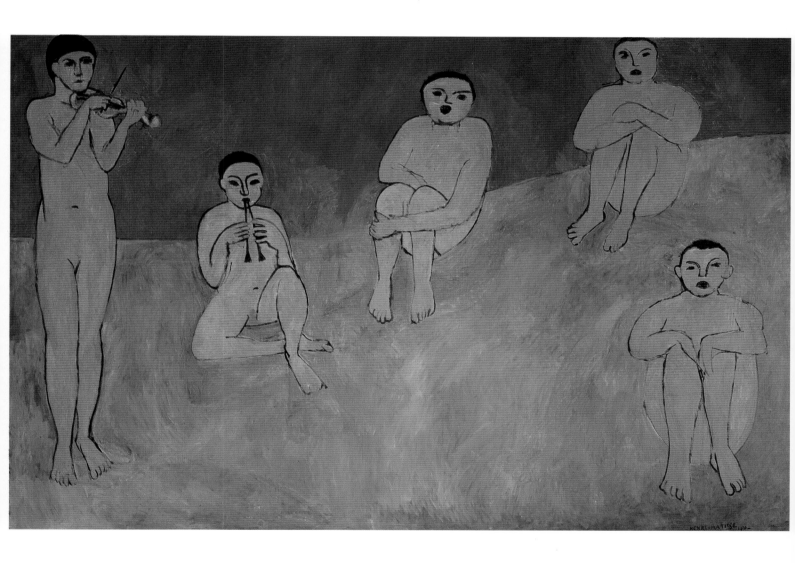

Music

1909–10, oil on canvas; 8 ft. 5⅝ in. x 12 ft 9¼ in. (260 x 389 cm). The Hermitage Museum, St. Petersburg.
Commissioned by Sergei Shchukin, the theme of music in this panel is illustrated by five figures that move across the space like notes on a staff. A standing violinist, naked but androgynous, is accompanied by a panpipe player and three singers. Shchukin required Matisse to tone down the nudity of the male figures with strategic brushwork before he would accept and hang the panels.

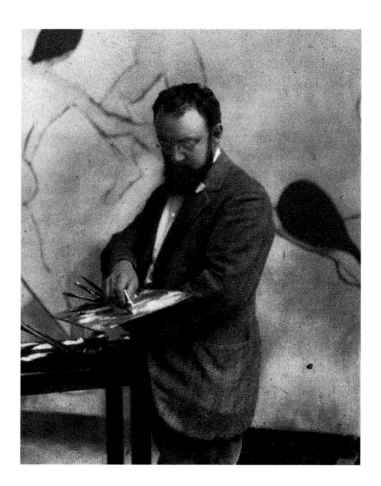

Matisse at Work on *Dance*

1909, photograph. The Museum
of Modern Art, New York.

When Matisse was planning *Dance*, he
remembered seeking inspiration one
Sunday afternoon at a popular dance
hall called the Moulin de la Galette
where he watched dancers perform
a spirited dance called the farandole.

Dance (I)

1909, oil on canvas; 8 ft. 6 in. x 12 ft. 9 in.
(259.7 x 390.1 cm). Gift of Nelson A.
Rockefeller in honor of Alfred H. Barr, Jr.,
The Museum of Modern Art, New York.

This is a large study Matisse painted
for a commissioned panel to be
installed in the stairway of the Moscow
palace of his important patron, Sergei
Shchukin. The motif of a ring of
dancers first appeared in the back-
ground of Matisse's painting *The Joy
of Life*. The simplified forms of the
dancers fill the vast canvas with the
rhythm of their movement while the
limited palette of pink, blue, green, and
black helps create a memorable image.

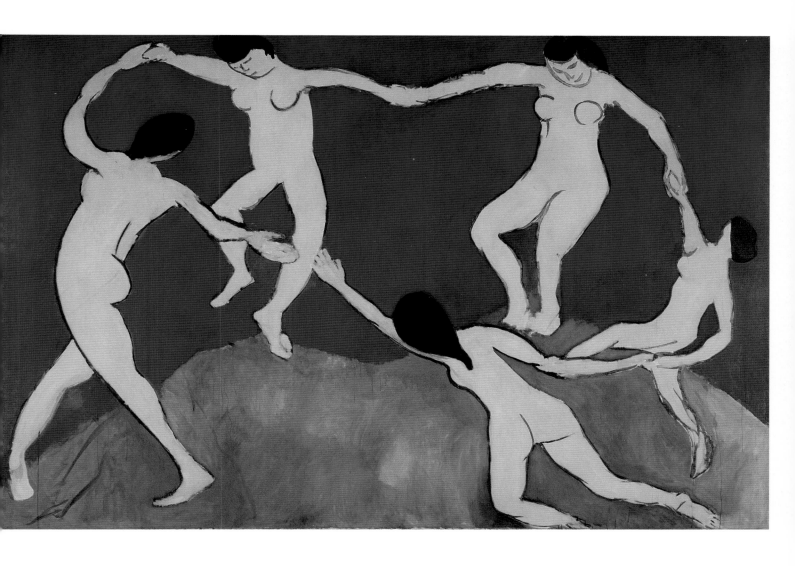

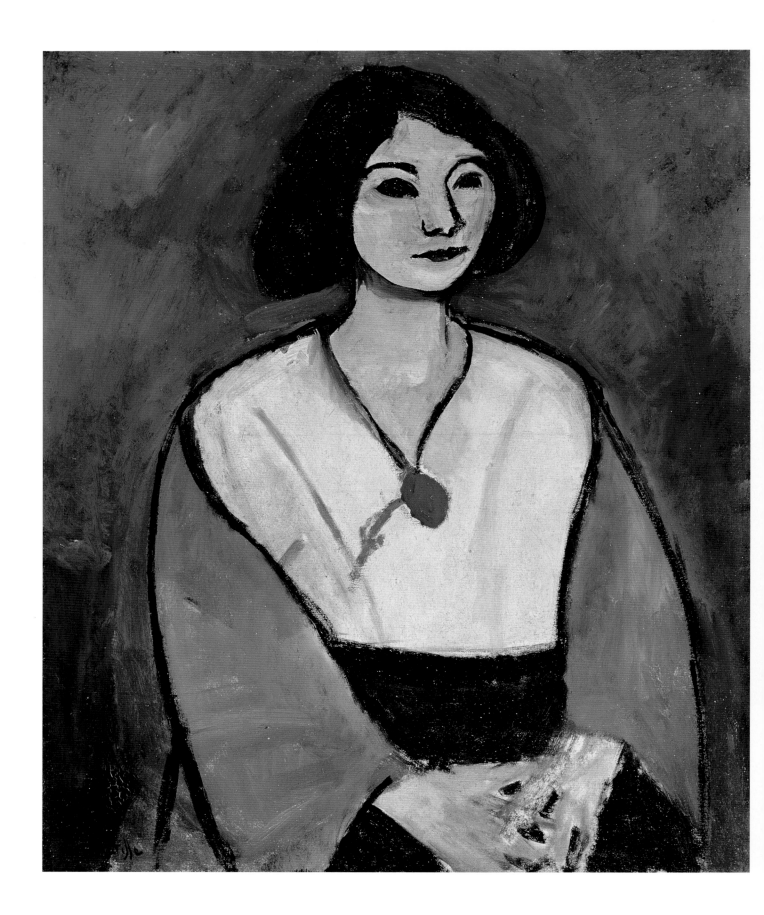

The Painter's Family

1911, oil on canvas; 56¼ x 6 ft. 4⅜ in. (143 x 194 cm). The Hermitage Museum, St. Petersburg. Although Matisse often painted his wife and daughter separately, paintings showing the whole family together are rare. In a room as filled with pattern as a Persian miniature, sons Jean and Pierre are playing checkers, daughter Marguerite stands holding a yellow book, and Madame Matisse sits sewing.

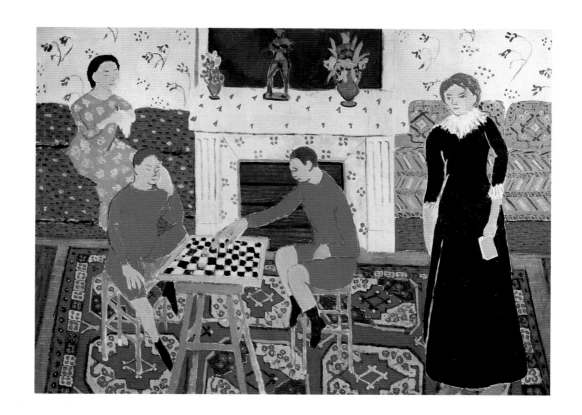

Woman in Green with Red Carnation
(Portrait of the Artist's Wife)

1909, oil on canvas; 25 x 21¼ in. (65 x 54 cm). The Hermitage Museum, St. Petersburg. Matisse married Amélie Parayre in January of 1898. This portrait shows both her strength and her gentleness in the simplified forms of her hair and features, and the harmony of green, black, and white shapes energized by the spark of the red flower at her neckline.

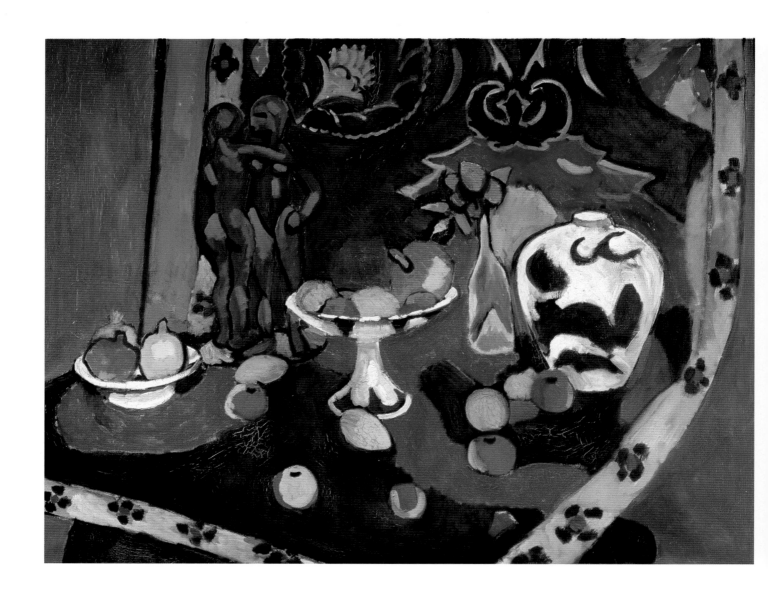

Fruit and Bronze

1910, oil on canvas; 35 x 45⅞ in. (89 x 116.5 cm). The Pushkin Museum of Fine Arts, Moscow.

This still life shows a Matisse sculpture of two women embracing among
a scattering of fruit, flowers, patterns, and crockery. Although the forms
of the sculpture are modeled, the painting emphasizes the surface's flatness
by using the play of color and pattern for a pleasing decorative effect.

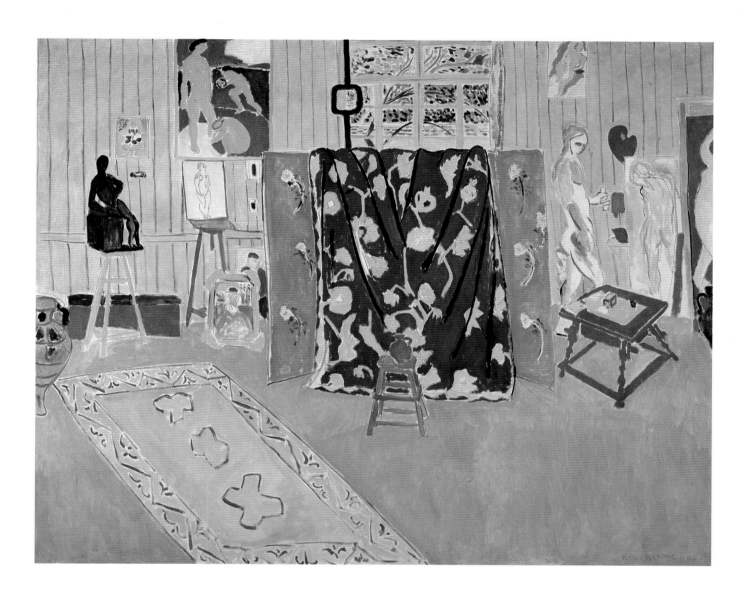

The Pink Studio

1911, oil on canvas; 70⅝ in. x 7 ft. 3 in. (179.5 x 221 cm). The Pushkin Museum of Fine Arts, Moscow.
This orderly glimpse into Matisse's studio at Issy-les-Moulineaux
makes an interesting comparison to *The Red Studio*.
Sculptures and paintings flank a large folding screen that
partly obscures a window.

Matisse at Work on
Portrait of Michael Stein

Autumn of 1916, photograph; Quai Saint-Michel
studio, Paris. The Museum of Modern Art, New York.
Michael and Sarah Stein were American
collectors who, along with Michael's
brother Leo and sister Gertrude, became
enthusiastic patrons as well as good friends
of Matisse. They brought Matisse's work
to the United States and introduced it to
their friends, to create an ever-widening
circle of admirers for the artist. (The por-
traits Matisse painted of Michael and Sarah
Stein are now in the collection of the
San Francisco Museum of Modern Art.)

Bather

1909, oil on canvas; 36 x 29⅛ in. (92.7 x 74 cm).
Gift of Abby Aldrich Rockefeller, The Museum of Modern Art, New York.
Matisse's interest in the bather theme began with his purchase of Paul Cézanne's
The Three Bathers, from which he continued to draw inspiration for many years.
The leaning stance of this figure is borrowed directly from that painting while
the deep blue background appears frequently in Matisse's paintings of this period.

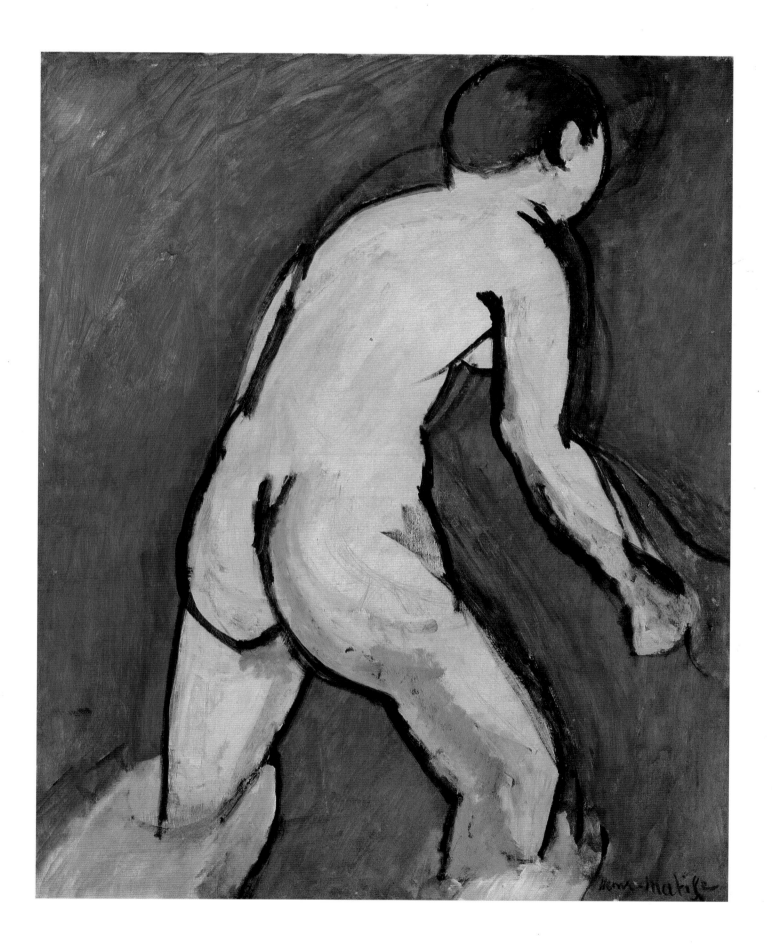

Corner of the Artist's Studio

1912, oil on canvas; 6 ft. 3 in. x 44⅞ in. (191.5 x 114 cm). The Pushkin Museum of Fine Arts, Moscow.

The charm of this painting is its simplicity. A bright canvas folding chair shares the corner with a large green vase topped with an exuberant potted plant. The pattern of a fabric drape and the flowers on the screen that supports it lead the eye back to the far upper corner where a fragment of the crouching nude in *Le Luxe* is visible.

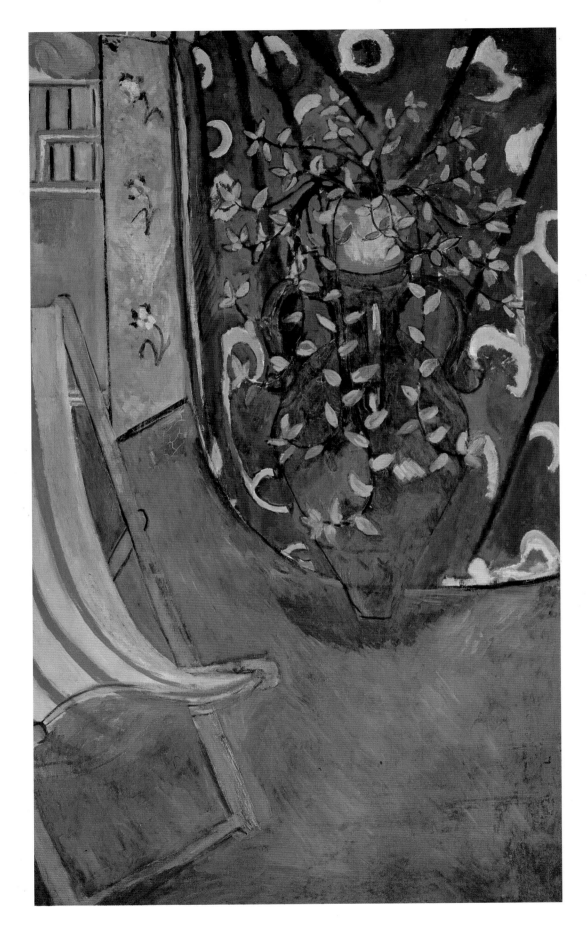

Chapter Three

THE ALLURE OF THE EXOTIC

lthough the new house at Issy was comfortable, Matisse found winters there a bit dreary. So in the winter of 1911–12 and again in the winter of 1912–13, he and Madame Matisse traveled south to Morocco to enjoy the warmth and sunshine of Tangier.

MOROCCO

The first winter, the Matisses were also accompanied by their painter friend André Marquet and the second winter by another friend, Charles Camoin. Matisse found new inspiration in Morocco; the different forms of the buildings, the gardens and plants, the people's faces and clothing styles all contributed to a new trend in his painting. In seeking inspiration in North Africa, Matisse joined in a tradition of French painters that included, most notably, the nineteenth-century artist Eugène Delacroix, who had also traveled to Morocco to paint. Many of the works of this period were bought by Matisse's enthusiastic patrons Shchukin and Morosov, and whisked off to Russia, where they remain to this day. These colorful and appealing paintings glow with blue and green as well as vibrant red and yellow.

Matisse already had a strong interest in Islamic art and owned pottery from an earlier trip to Algeria that he had been using in his still lifes. His impressions of the light and architecture of Morocco, however, were particularly vivid both during and after these winter trips. *Landscape Viewed from a Window* is a study in blue with contrasting white buildings, the green roof of the English church, and patches of yellow ocher. It is a fairly faithful view of what Matisse could have seen from where he was staying—

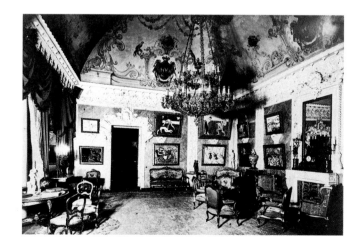

including buildings and people in a landscape. However, the overall blue of the window frame, curtain, sky, and foliage has a flattening effect like that of the enveloping red background and foreground of *Harmony in Red*.

"Matisse Room" in the Home of Sergei Shchukin, Moscow

1912, photograph. The Museum of Modern Art, New York. Shchukin was a wealthy textile importer from Moscow who came from a family of art collectors, but he was the only one of five brothers with a passion for modern art. For a number of years he bought quantities of Matisses, sometimes before the paint was even dry. The Paris art world dubbed him "the mad Russian" but his taste ensured that Russia now holds one of the world's greatest Matisse collections.

❝ *We work toward serenity through simplification of ideas and of form. The ensemble is our only ideal. Details lessen the purity of the lines and harm the emotional intensity; we reject them.* **❞**

—HENRI MATISSE

QUOTED IN *INTERVIEW WITH MATISSE* BY CHARLES ESTIENNE (1909)

Zorah on the Terrace shows a young local girl in traditional dress kneeling near a bowl of goldfish, while a shaft of light rakes across the wall above her head. There is a quietness in this painting, a timelessness that is enchanting, but also verges on nostalgia. The second winter, Matisse tracked Zorah down with some difficulty so she could pose for him again, which she did. *Zorah Standing* is another painting for which she posed. In it, the gentleness of the former picture is replaced by a solemn, ceremonial quality that has the frontality and flatness of Russian icon painting. The brilliant red background serves to flatten and define the image visually in much the same way as the gold background of an icon painting creates an illusion of holy aura.

The Casbah Gate is a view through a keyhole-shaped doorway. Beyond the doorway are rooftops and the shapes of buildings, and a sketchy figure is barely visible to one side of a magical doorway as a stream of red light pours through onto the floor. Matisse also did several paintings of the *Riffian*, a man from the mountainous Rif area—and a member of a tribe of ruggedly fierce people who traditionally dressed in a very colorful manner. French critic Marcel Sembat summed up the romantic French attitude toward the Rif when he asked, "Can you look upon this splendid barbarian without dreaming of the warriors of yesteryear?"

It is not always clear which paintings Matisse painted during his first trip to Morocco and which were from his second trip, but, as a group, these painting have great appeal—and are increasingly flat and decorative. In *The Moroccan Café*, which was bought by Shchukin for ten thousand francs, Matisse has simplified the seated, robed figures to the point of omitting all facial features. The muted colors of this composition suggest the repose of the figures themselves, it is a quiet, meditative work. But it is also the work of an outsider, someone looking in at a different world, an alien and exotic culture. For Matisse, the people of Morocco seem to have something of the same colorful exoticism that he also found in the bowl of goldfish that he so often includes in compositions of this period.

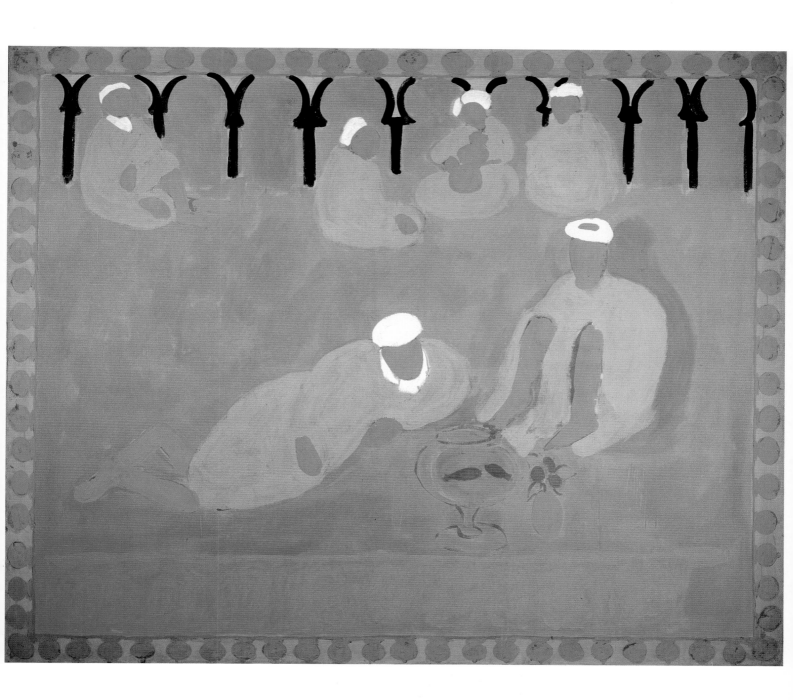

The Moroccan Café

1912–13, distemper on canvas; 69¼ x 6 ft. 10⅝ in. (176 x 210 cm). The Hermitage Museum, St. Petersburg.

Muted colors suggest repose, while the simplicity of the figures, who lack features and detail, adds
to the tranquillity of the scene. Originally the figures had robes of different colors, facial features,
slippers, and pipes, but Matisse repainted the composition to omit all but the most essential elements.

Tangier: The Casbah Gate

1912–13, oil on canvas; 45⅝ x 31 in. (116 x 80 cm). The Pushkin Museum of Fine Arts, Moscow. Light, color, and the forms of Moorish architecture all contribute magic to this view of red light pouring through a doorway. Beyond, in a sort of artistic shorthand, Matisse has indicated the buildings of the city. A figure to one side of the doorway is so unresolved, it almost looks sketched upon the wall.

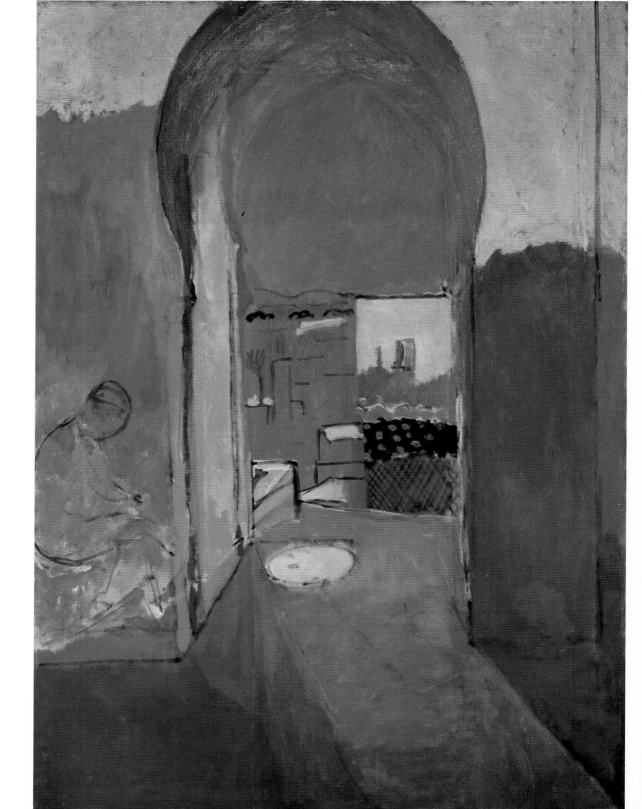

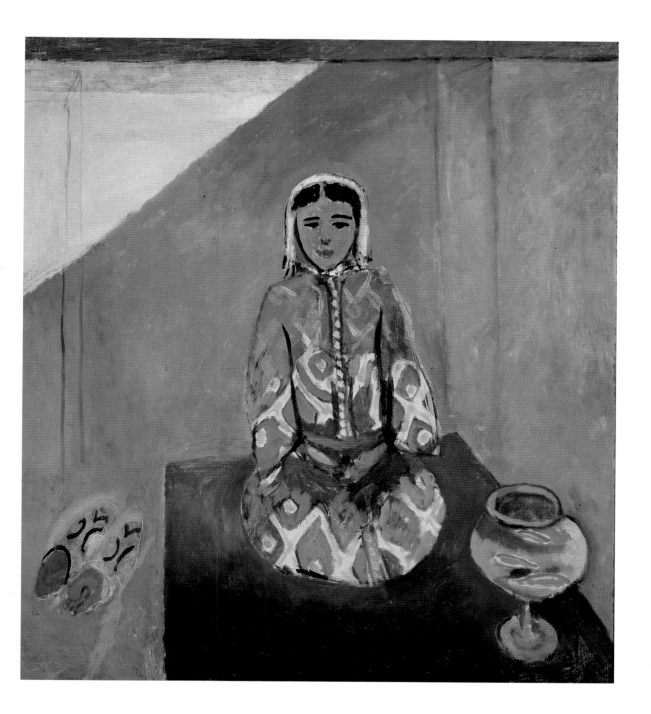

**Tangier:
Zorah on
the Terrace**

*1912–13, oil on canvas;
45¼ x 39⅜ in.
(115 x 100 cm).
The Pushkin Museum
of Fine Arts, Moscow.*

A young girl kneels
next to a bowl of
goldfish in the shal-
low space of an en-
closed terrace. The
muted blues of the
painting are bright-
ened by a wedge
of sunlight above
Zorah's head, the
white diamond
pattern of her robe,
and the red interior
of the pair of slip-
pers, which seem
to float to one side.

Matisse successfully showed his Moroccan paintings at the Bernheim-Jeune Gallery in early 1913, together with a number of sculptures and drawings. *The Moroccan Café* was the most admired and controversial work in the show. It prompted some choice comments from Marcel Sembat, who praised the work for its simplicity, serenity, and decorativeness. Originally the figures had had features, pipes, slippers, and robes of varying colors, but Matisse had revised the composition in the interest of simplicity. The paintings that were not bought by Matisse's Russian collectors were purchased by an enthusiastic grouping of German, Swiss, and Scandinavian admirers.

The time that Matisse spent at home in Issy between his Moroccan trips was also highly productive. He produced a series of colorful works, many with deep blue backgrounds, on the subject *Nasturtiums with "Dance."* Here, a fragment of his large *Dance* painting, part of the circle of nude, ecstatic dancers, forms the background of a corner of the studio that also holds a wooden chair and a stool topped with a vase of nasturtiums. Matisse also combined the goldfish in a bowl theme with various still life objects, most notably his own sculpture of a reclining female nude. The sculpture is a stand-in for the model in the studio, which is filled with flowers and plants—a modest personal vision of paradise.

Matisse had also been producing a number of sculptures during this period. His first *Back* sculptures date from 1909—the series of bronze reliefs showing a nude standing woman from behind, continued until 1929. The *Back* sculptures owe their inspiration to the work of Cézanne, notably *The Three Bathers*, which Matisse had bought some years earlier, and which was a continuing source of inspiration to him. In all, Matisse completed four *Back* reliefs, ranging from simple and graceful to monumental and columnar. Matisse also

Matisse and Madame Matisse in the Studio at Issy-les-Moulineaux, with the Unfinished *Bathers by a River*

May 1913, photograph by Alvin Langdon Coburn. International Museum of Photography at George Eastman House, Rochester, New York.

Matisse and his family enjoyed a period of prosperity in the years before the First World War. They were able to buy a house and land in a comfortable suburb of Paris where they were surrounded by their gardens and Matisse's artwork.

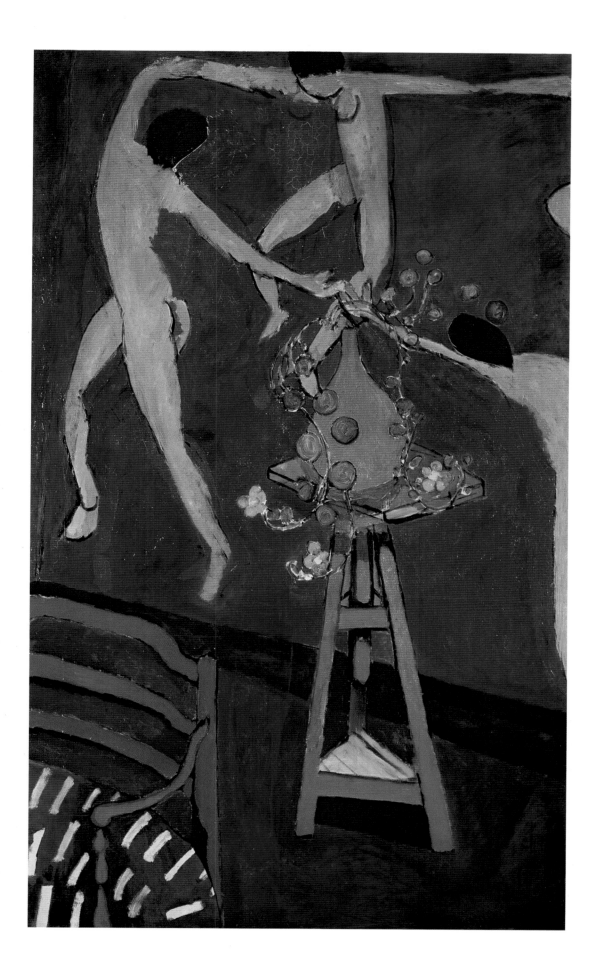

**Nasturtiums
with "Dance" (II)**

*1912, oil on canvas; 6 ft. 3 x
44⅞ in. (190.5 x 114 cm).
The Pushkin Museum of
Fine Arts, Moscow.*
A painting within a
painting was a popular
motif in Matisse's art
at the time he painted
Dance. Here the energetic
forms of part of the ring
of dancers appear in a
corner of the studio that
holds an armchair and
a vase of nasturtiums on
a plant stand. The deep
blue of the foreground
and background is punc-
tuated by the red furni-
ture and the rosy nudes.

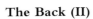

The Back (II)

*1913, bronze; 6 ft.
2¼ in. x 47⅝ x 6 in.
(188.5 x 121 x 15.2 cm).
Mrs. Simon Guggenheim Fund, The
Museum of Modern Art, New York.*
One of the four large
relief sculptures of a
woman's back that Matisse
executed over a twenty-
year period, the *Back* series
shows the artist at work in
a process of increasing sim-
plification. *The Back (II)* is
still somewhat naturalistic,
although the roughly chis-
eled planes of the figure are
already becoming more
vertical than the curving
posture of *The Back (I)*.

❝ *He is like one of those rare writers for whom every word has meaning, every turn of phrase its weight.* **❞**

—*MICHEL PUY*
MERCURE DE FRANCE, "THE LATEST IN PAINTING" (JULY 16, 1910)

sculpted many versions of a bust of *Jeanette* which he subjected to increasing simplification and distortion.

In March of 1912, Alfred Stieglitz's 291 Gallery in New York gave Matisse his first show of sculpture without any painting. However American audiences were apparently not ready for Matisse's sculpture. The critics were struck by "gooseflesh" and "horrible repulsion" when viewing his work, and no work was sold—although *The Serf* was almost bought by wealthy art collector Gertrude Vanderbilt Whitney. She changed her mind, though, under pressure when a fashionable portrait-painting friend argued her out of the purchase.

CONTROVERSY AND WAR

Matisse's international following continued to grow, and 1912 saw an exhibition of his work in Cologne, where his paintings were somewhat outnumbered by Picasso's. At the Second Post-Impressionist Exhibition in London, arranged by critic Roger Fry, Matisse's works dominated the French offerings, and were honored by being reproduced for the color frontispiece and as a number of plates in the catalogue.

But by far the most controversial exhibition of Matisse's work was at the famed Armory Show of 1913 in New York. This international exhibition of modern art created widespread critical furor, and was attended by over a quarter of a million visitors. People lined up to view and exclaim over Marcel Duchamp's Cubist painting *Nude Descending a Staircase,* which had the dubious honor of being the most misunderstood and reviled painting in the exhibition. Matisse, who was represented by thirteen paintings, three drawings, and a large sculpture, received a good deal of flack himself. Critics responded to his works by calling them "the drawings of a nasty boy" and dismissing his pictorial ideas as "either trivial, monstrous, or totally lacking"—as well as ugly, brusque, epileptic, and violent.

Matisse tried to save his reputation with the American public in a *New York Times* interview with Clara T. MacChesney that year, prevailing upon her to "tell the American people that I am a normal man; that I am a devoted husband and father, that I have three fine children, that I go to the theater, ride horseback, have a comfortable home, a fine garden that I love, flowers, etc., just like any man."

Back in Paris at the Autumn Salon of 1913, Matisse's only offering was the *Portrait of Mme Matisse.* Although the colors—glowing blue, green, and yellow ocher, with black and pink accents—are related to the Moroccan pictures, there is a cool subdued quality to the painting that is reinforced by the

❝ *There was something very sympathetic about Matisse. With his regular features and his thick, golden beard, he really looked like a grand old man of art.* **❞**

—FERNANDE OLIVIER
PICASSO ET SES AMIS

**Portrait of
Mme Matisse**

1913, oil on canvas;

57 x 38⅛ in. (145 x 97 cm).

The Hermitage Museum,

St. Petersburg.

This deceptively simple
likeness of the artist's
wife seated in their
garden at Issy required
over one hundred
sittings. Her face is an
oval mask, her eyes two
dark voids, her hands
barely defined—and
yet this portrait has the
strength of Madame
Matisse's personality.
Somber blues, grayish
flesh tones, a tailored
suit, a perky hat, and
a comparatively bright
shawl are combined into
a striking impression.

masklike features of Madame Matisse's face and the tailored line of her suit. The simplicity of the face is deceptive—Matisse required over one hundred sittings to complete the portrait. Critic Guillaume Apollinaire called it a "masterpiece" and the best thing in the Salon. The painting was bought by Shchukin, the last purchase he made from Matisse before the war and the Russian Revolution overtook him. After the revolution Shchukin arrived in Paris as a refugee, but he was no longer interested in collecting art, and saw little of Matisse personally. During the winter of 1913–14, Matisse went back to his old studio on the Quai Saint Michel, where he painted a number of works showing the interior of the studio in dark and subdued tones.

When international tension erupted into war in August of 1914, Matisse, then forty-five, was rejected for service. Many of his friends and younger colleagues went to war—Derain was on the front lines, Braque was called for service, and Vlaminck was stationed at the port of Le Havre. Both of Matisse's sons were to serve as well, as soon as they turned eighteen.

As the Germans approached Paris, Matisse sent the children south to Toulouse, where he, his wife, and his rolled-up paintings soon followed. They settled in at their villa in Collioure in September, where Matisse, who was deeply disturbed by the war, found painting demanded too much concentration. He turned instead to etching and obsessive violin playing. (Matisse once said of his violin, if he lost his sight, he would support his family by playing the violin on the street.) Later in 1914, Matisse returned to Issy and his former Paris studio, where he remained except for brief trips.

At Collioure, Matisse developed a friendship with the Spanish Cubist painter Juan Gris, and he extended himself in various ways to help out during Gris's financial crisis, including paying Madame Gris to model for him for a series of etchings. Meanwhile, in New York, an artist and critic named Walter Pach was organizing a representative show of Matisse's work at the Montross Gallery on Fifth Avenue. Pach provided thoughtful written commentary and there was a well-illustrated catalogue, and a generous amount of publicity.

It was during this time that Matisse's work stirred the interest of two new American collectors, John Quinn, a brilliant New York lawyer, and Dr. Albert C. Barnes, a research chemist grown wealthy from his patent formula for an antiseptic called Argyrol. During the 1920s Dr. Barnes went on to amass the greatest collection of Matisse works in the United States, which he added to his already impressive collection of Impressionist and

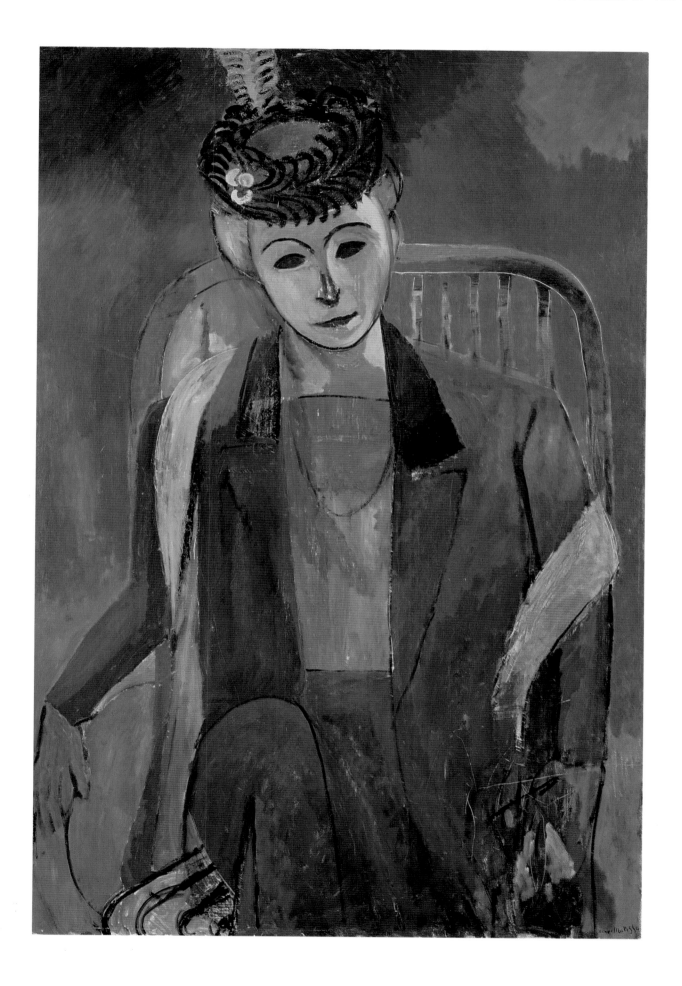

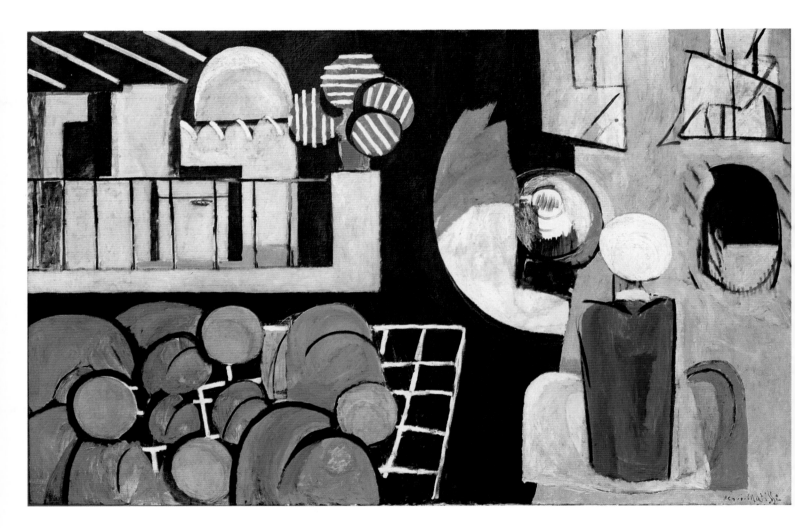

The Moroccans

1915–16, oil on canvas; 71⅜ x 9 ft. 2 in. (181.3 x 279.4 cm).

Gift of Mr. and Mrs. Samuel A. Marx, The Museum of Modern Art, New York.

Forms are treated in a geometric manner in this large work, which distills Matisse's memories of Morocco. A large patch of round melons, seated turbaned figures, a balcony railing with a potted plant, and the forms of the city skyline are carefully arranged in a harmony of circles and rectangles. Spots of color enliven the primarily black and white scene.

Post-Impressionist paintings at his private museum in Merion, Pennsylvania. However, by far the most important collector of Matisse's work between 1913 and 1925 was a Danish corn merchant, Christian Tetzen Lund of Copenhagen.

SIMPLIFICATION AND THEORY

During the war years there were no salons and exhibitions in Europe, and consequently no opportunity for Matisse's works from his period of geometric abstraction to be seen publicly. In the years 1916–17 Matisse was also painting two monumental canvases which he did not sell: *The Moroccans* and *Bathers by a River.*

The Moroccans is an evocation of his experiences in North Africa, but more simplified and abstract than his previous works on the subject. It shows robed and turbaned figures seated near a large patch of melons with a city skyline visible beyond a terrace. At first glance, the forms read mostly as circles and rectangles with islands of colors dominated by black and white. The forms only become meaningful objects after some puzzlement.

Bathers by a River was the largest canvas Matisse completed, second only to *Music, Dance,* and the murals he would do in the 1930s for Dr. Barnes. *Bathers by a River* and *The Moroccans* are Matisse's answer to both Cézanne and Cubism. In both works he distances himself from the emotional content of the paintings, choosing to concentrate instead on the archi-

> **❝** *I want to reach that state of condensation of sensations which makes a painting. I might be satisfied with a work done at one sitting, but I would soon tire of it; therefore, I prefer to rework it so that later I may recognize it as representative of my state of mind.* **❞**
>
> —HENRI MATISSE
> *NOTES OF A PAINTER (1908)*

❝ *I owe my art to all painters. When I was young, I worked in the Louvre, copying the old masters, learning their thought, their technique. In modern art, it is indubitably to Cézanne that I owe the most.* **❞**

—HENRI MATISSE
FROM AN INTERVIEW WITH RUSSELL WARREN HOWE (1949)

Matisse in His Studio at Issy-les-Moulineaux with the Unfinished *Bathers by a River*

May 1913, photograph by Alvin Langdon Coborn. International Museum of Photography at George Eastman House, Rochester, New York.

The painting on which Matisse is at work is his largest canvas (just under 13 feet [4 meters] long), with the exception of his monumental murals commissioned by Sergei Shchukin and Dr. Barnes. He did not exhibit or sell this work for many years after he had painted it.

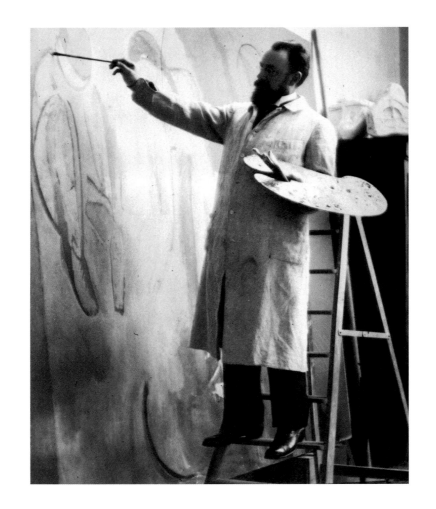

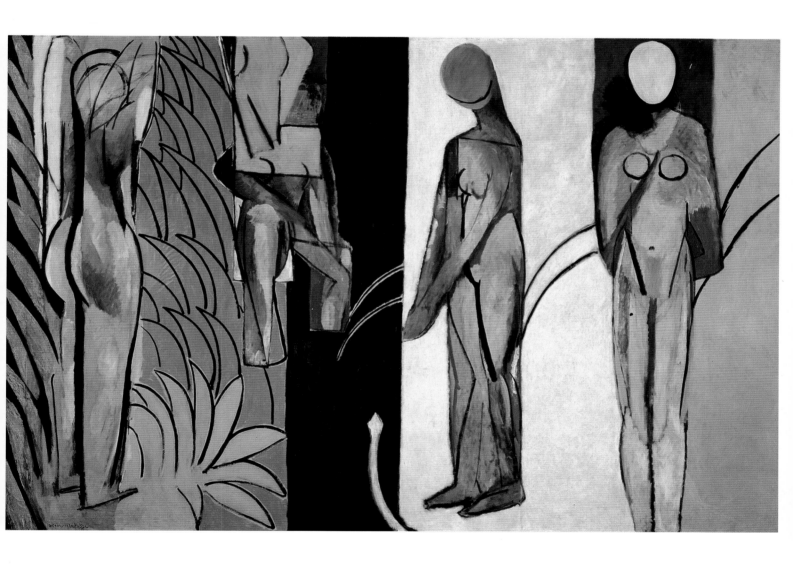

Bathers by a River

1916, oil on canvas; 8 ft. 7 in. x 12 ft. 10 in. (261.8 x 391.4 cm).

Charles H. and Mary F. S. Worcester Collection, The Art Institute of Chicago.

Matisse's love for Cézanne's *The Three Bathers* is once again a factor in this monumental painting. An experimental interest in Cubist space and the strong value contrasts of black and white distinguish the forms of the nudes and divide the composition into a number of interconnected vertical bands.

Piano Lesson

1916, oil on canvas;
8 ft. x 6 ft. 11¾ in.
(245.1 x 212.7 cm).
Mrs. Simon Guggenheim
Fund, The Museum of
Modern Art, New York.
Seated at the piano,
a child sits facing out,
while behind is a
woman on a high stool.
An open window, a
sculpture of a nude,
and the solid pyramid
of a metronome com-
plete the image, which
is both enigmatic and
stark. The severity of
the geometric forms
is broken only by the
ornate wrought-iron
balcony, the ornamen-
ted music stand on the
piano, and the bright
splash of pink against
the gray, black, and white.

tecture of forms in space, the problems of a
purely intellectual composition.

Cubism, as seen in the work of Picasso,
Braque, and Gris, was by this time already of
more interest to a younger generation of
artists than Matisse's work. Matisse, instead of
resenting this usurpation, chose to participate
in the experiments of his friends and rivals.
Matisse found that "Cubism interested me,
but it did not speak to my deeply sensory
nature, to the great lover that I am of line, of
the arabesque. . . ."

In an interview with the French poet and
critic André Verdet, Matisse admits that
Cubism brushed up against him, and that he
and Picasso, during 1912 and 1913, "cared
passionately about our respective technical
problems. There is no question that we each
benefited from the other." Cubism posed
more intellectual and technical problems
with the painted canvas than Matisse's sensual
approach to the world, which was bound up
with color, curves, and an emotional response
to his subject. Cubism challenged him for a
while, but soon he was ready to move on.

Matisse also moved through a flirtation
with abstraction between 1914 and 1917. This
can be seen in such paintings as *The Yellow
Curtain* (c. 1915), *Gourds* (c. 1915–16), *View
of Notre-Dame* (1914), and *French Window at
Collioure* (1914). His abstract tendencies are
still in evidence in *Piano Lesson* (1916).

Piano Lesson shows a child sitting at a Pleyel
piano, while a faceless woman teacher on a
high stool sits behind him. Through the open
window some green is visible, which echoes
the triangular shape of the metronome sitting
in the foreground. To one side, a small languid
female nude—one of Matisse's sculptures—is
visible. The subject, though, is less important

than the interplay of severe lines, forms, and
colors. The severity of the composition is
relieved only by the curvy nude, the
wrought-iron railing, and the ornament of
the piano's music stand. Psychologically, the
interactions of the figures and the nude could
be interpreted to hint at some Freudian sex-
ual drama, but the musical qualities of form,
color, and line take precedence. Matisse him-
self speaks for his formal concerns when he
says: "Colors have a beauty of their own
which must be preserved, as one strives to
preserve tonal quality in music."

Music, of course, was and continued to be an
important part of Matisse's life, both in his own
violin playing, and as a recurring theme in his
art. The following year, Matisse painted another
version of this subject in *The Music Lesson*, the
only other picture besides *The Painter's Family*
(1911) where he shows his whole family gath-
ered together. The painting gathers Madame
Matisse, Marguerite, Pierre, and the now adult
Jean, eighteen years of age and about to go off
to the army at the height of World War I. Jean
sits reading and smoking while Marguerite and
Pierre are at the piano. In the garden Madame
Matisse is sewing in the presence of a large
reclining nude sculpture, while the woman on
a high stool, her head cut partially off, sits in the
background. The violin sits in its open case
upon the piano next to a book of Haydn's
music. The change in Matisse's painting style is
dramatic—the scene is realistically if simply
painted, with lightness and sensuality. Colors
are brighter, and the severe architecture of
Piano Lesson has receded. Matisse seems to have
returned to his philosophy that "a painting
in an interior spreads joy around it by the col-
ors," and a "painting on a wall should be like a
bouquet of flowers in an interior."

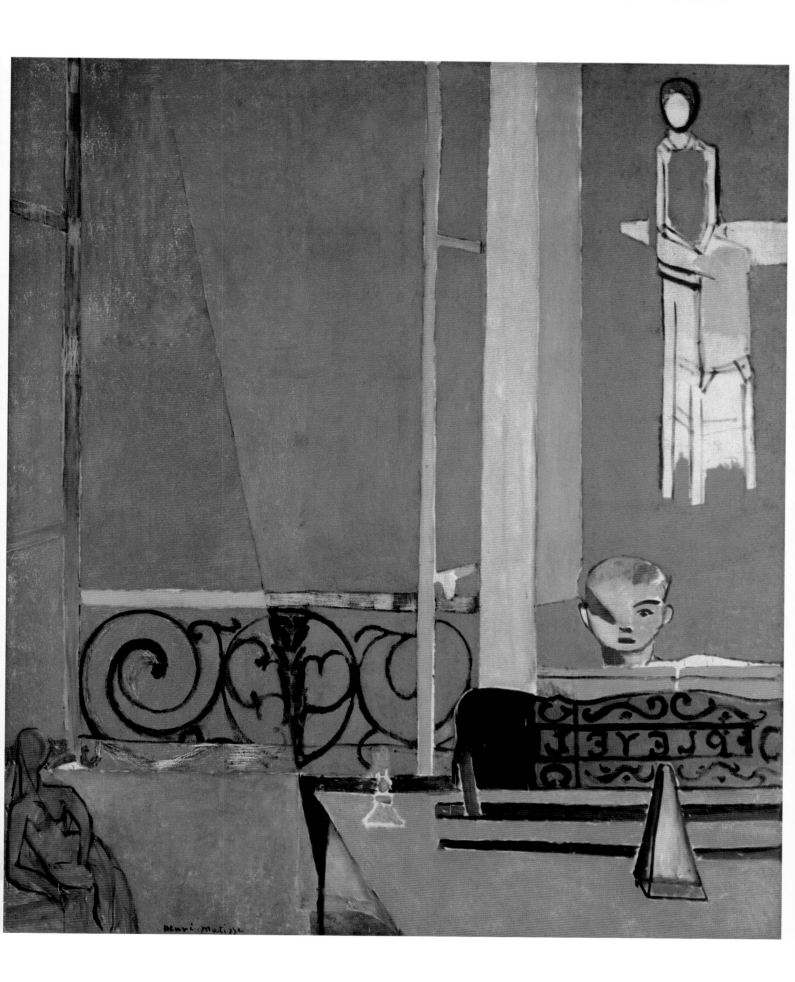

Henri Matisse

" *Painting is a blind man's profession. He paints not what he sees, but what he feels, what he tell himself about what he has seen.* **"**

—PABLO PICASSO

View of Notre-Dame

1914, oil on canvas; 58 x 37⅛ in. (147.4 x 94.3 cm). Acquired through the Lillie P. Bliss Bequest, and the Henry Ittleson, A. Conger Goodyear, Mr. and Mrs. Robert Sinclair Funds, and the Anna Erickson Levene Bequest given in memory of her husband, Dr. Phoebus Aaron Theodor Levene, The Museum of Modern Art, New York.

Matisse approaches abstraction in this view of Notre-Dame seen from his studio window. The mass of the ornate Gothic cathedral is reduced to two simple rectangles highlighted by patches of white and a green tree; the doors and windows have been omitted. The bridge, river, and the rest of the scene are indicated by a few straight black lines brushed on the almost uniformly blue canvas.

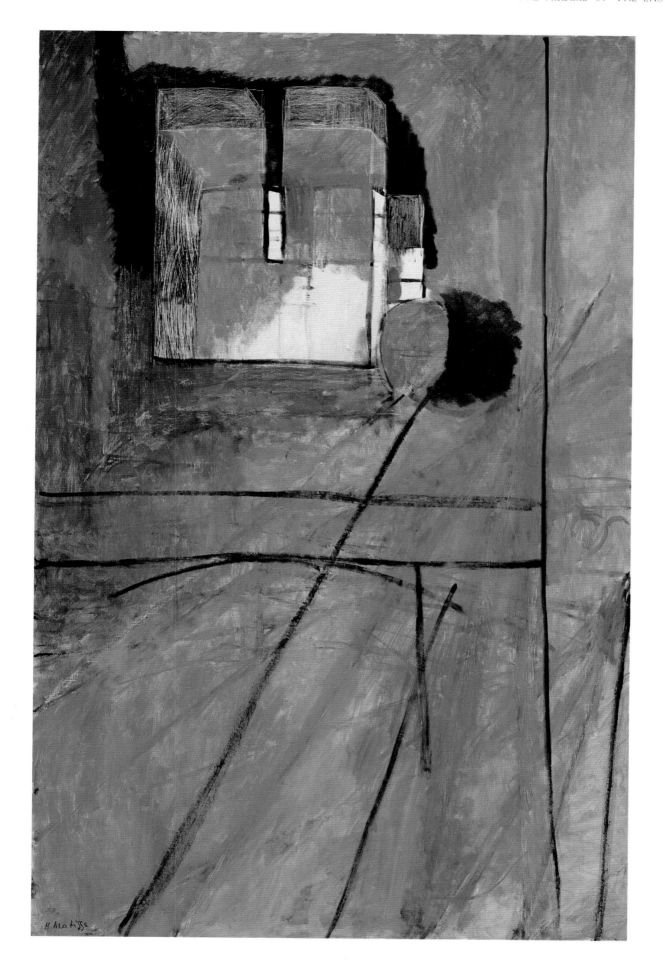

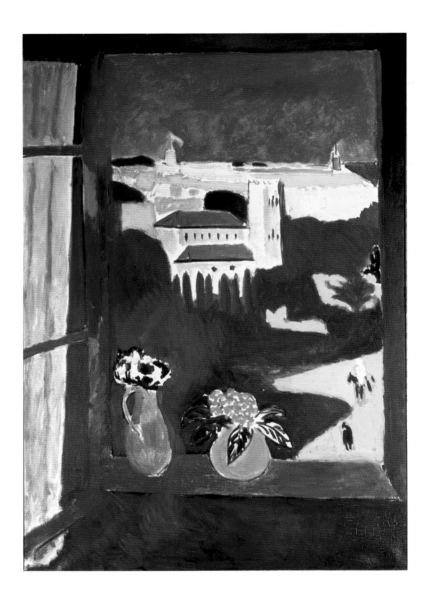

Landscape Viewed from a Window

1912, oil on canvas; 45¼ x 31 in. (115 x 80 cm). The Pushkin Museum of Fine Arts, Moscow.
Painted during a visit to Tangier, this is one of many works in which
Matisse would explore the subject of the open window. Here he
incorporates the curtain, windowsill, and several jugs of flowers along
with a vista of rooftops seen from afar, all in vibrant shades of blue.

**Periwinkles/
Moroccan Garden**

1912, oil on canvas;

46 x 32¼ in.

(116.8 x 82.5 cm).

Gift of Florene M.

Schoenborn, The Museum

of Modern Art, New York.

Painted on a visit to
Morocco, this land-
scape reflects Matisse's
delight in his subject.
The forms of trees
and leaves are broadly
and simply painted
in lyrical curves
that give the painting
an abstract quality.

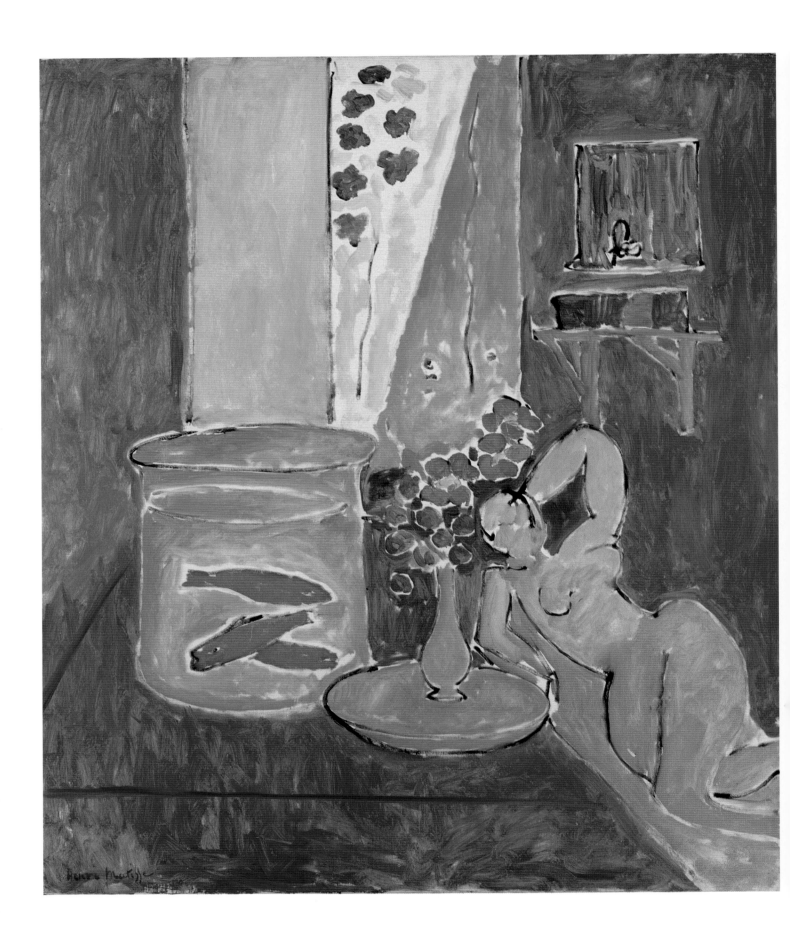

Goldfish

1912, oil on canvas; 57 x 38⅛ in. (146 x 97 cm).

The Pushkin Museum of Fine Arts, Moscow.

Matisse painted a number of works featuring a bowl of goldfish. Their bright forms make an effective focal point in many of his appealing still lifes from this period. Combined with flowers and tropical foliage they lend an exotic atmosphere to this painting of paradise on a tabletop.

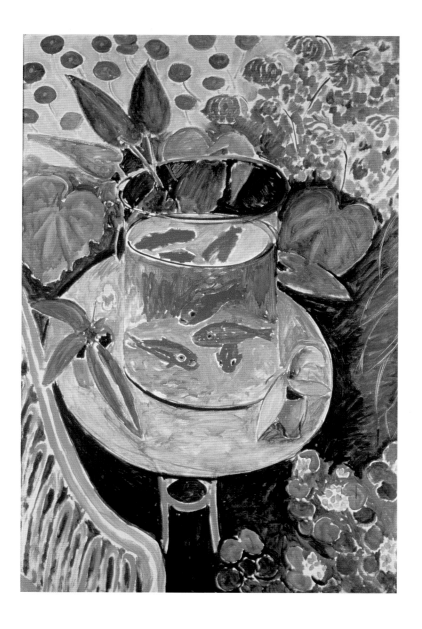

Goldfish and Sculpture

1912, oil on canvas; 45¾ x 39 in. (116.2 x 100.5 cm).

Gift of Mr. and Mrs. John Hay Whitney, The Museum of Modern Art, New York.

Matisse isolates his motifs with a thin black outline and/or a thin white line of bare canvas against a uniformly blue ground. His ceramic sculpture, *Reclining Nude*, stands in for a live model, and is grouped with a vase of bright nasturtiums and a bowl of goldfish. Behind, a window or doorway opens up the otherwise flat space with a suggestion of daylight and trees.

Henri Matisse at Issy-les-Moulineaux

May 1913, photograph by Alvin Langdon Coborn. International Museum of Photography at George Eastman House, Rochester, New York. Matisse, seen here at rest, seated on the steps of his home, was a tireless craftsman who frequently reworked his sculptures and paintings many times. He often created multiple versions of a work in order to fully explore the expressive potential of his subjects.

The Blue Window

1913, oil on canvas; 51 x 35⅝ in. (130.8 x 90.5 cm).
Abby Aldrich Rockefeller Fund, The Museum of Modern Art, New York.
A view from the Matisse bedroom at Issy-les-Moulineaux outside of Paris is both playful and daring. The still life objects in front of the window include a yellow pincushion stuck with black hatpins, several vases, a sculpture of a head, a lamp, a mirror, and a yellow dish holding a jeweled brooch. Matisse has arranged for trees to grow out of the head and the lamp, while the illusion of space is flattened by the overall blue of foreground and background.

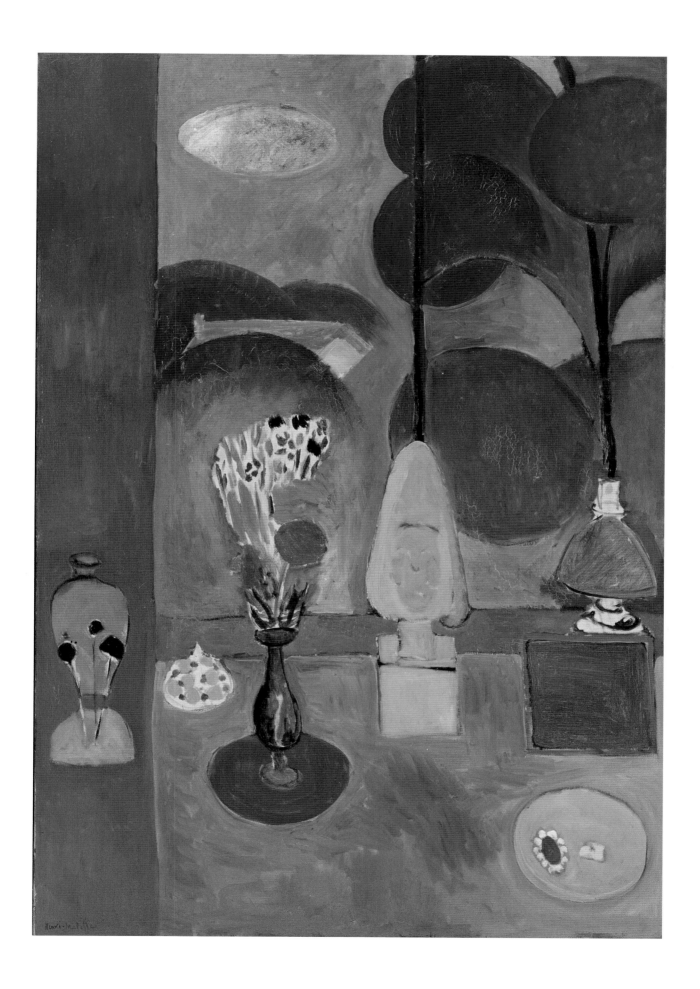

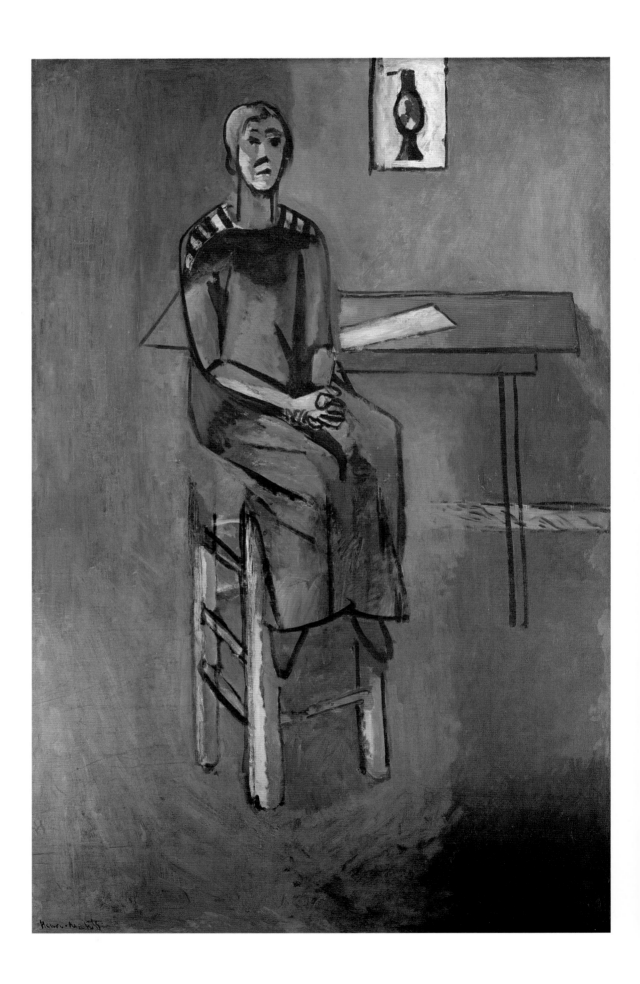

Henri Matisse in His Living Room at Issy-les-Moulineaux

May 1913, photograph by Alvin Langdon Coborn. International Museum of Photography at George Eastman House, Rochester, New York.

By 1913, Matisse had achieved financial success—thanks to an enthusiastic circle of collectors of many nationalities. He had spend the two previous winters painting in Morocco, where he produced a new body of work that he showed at the Bernheim-Jeune Gallery in Paris to critical acclaim and the delight of his collectors.

Woman on a High Stool (Germaine Raynal)

1914, oil on canvas; 57⅞ x 37⅝ in. (147 x 95.5 cm). Gift of Florene M. Schoenborn and Samuel A. Marx (the former retaining a life interest), The Museum of Modern Art, New York.

Severity and simplicity mark this portrait in which the subject is perched on a sturdy stool in the middle of a room that holds only a table with a single sheet of paper, and a drawing (by Pierre Matisse) of a vase tacked on the wall. Grayness seems to envelope the room and the figure, who seems almost to float upon the canvas, held in place only by a web of black lines.

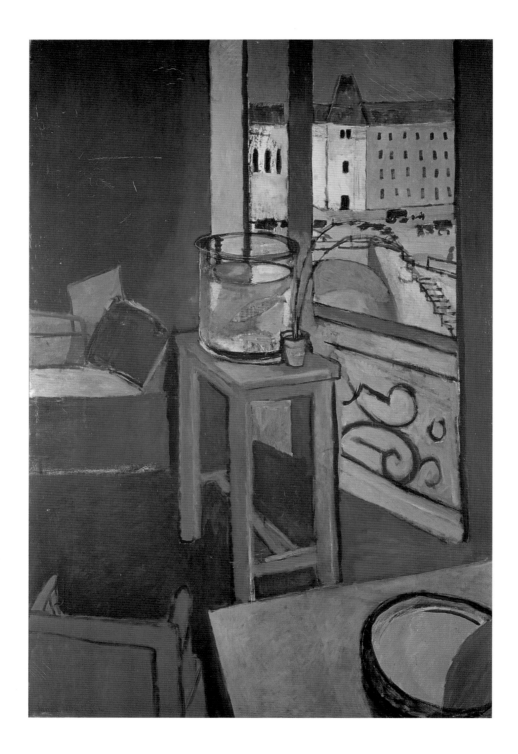

Interior with a Goldfish Bowl

1914, oil on canvas; 57⅞ x 38⅛ in. (147 x 97 cm). Musée National d'Art Moderne, Centre Georges Pompidou, Paris.

A glimpse into Matisse's Paris studio shows a bowl of goldfish by the window that
looks out across the Seine at the Petit Pont and the Préfecture de Police. Cool
gray and blue tones predominate in Matisse's paintings of this period, relieved only
by a few bright accents—here the goldfish, the railing, and the rim of a bowl.

The Painter in His Studio

1916, oil on canvas; 57⅝ x 38⅓ in. (146.5 x 97 cm).

Musée National d'Art Moderne, Centre Georges Pompidou, Paris.

Here, Matisse has painted a simplified image of himself, palette in hand, seated at his easel
in the Quai Saint-Michel studio. On the easel is a portrait of his favored model of the moment,
Lorette. Lorette is shown twice—she is also sitting for the painting in the corner of the studio.

The Three Sisters

1917, oil on canvas; 36¼ x 28¾ in.
(92 x 73 cm). Collection Walter-
Guillaume, Musée de l'Orangerie, Paris.
In one of a group of paintings
of this subject that also includes a
triptych, Matisse shows his Italian
model Lorette seated together
with her two sisters. Painted in a
noticeably brighter and less for-
mally structured manner than his
paintings of the preceding years,
this work signals a shift in Matisse's
style to his accessible Nice period.

Interior with Violin Case

1918–19, 28¾ x 23⅝ in. (73 x 60 cm). Lillie P. Bliss Collection, The Museum of Modern Art, New York.
In this early work of the Nice period, Matisse paints the charming details
of his luxurious room at the Hôtel de la Méditerranée on the Nice waterfront.
Light floods in through the open French doors and balcony railings onto the
dressing table with its black oval mirror, letter folder, and ornate chair. The
open case of Matisse's violin rests across the arms of a comfortable armchair.

Chapter Four

ODALISQUES AND IDYLLS

fter visiting Nice briefly in the summer of 1916, Matisse went south in 1917 to spend his first winter there. Thus he began a pattern of winters in Nice and summers in the north that was to endure for over thirty years. At first he stayed in hotel rooms alone; later he took an apartment and was joined by his wife.

THE REFUGE OF NICE

Nice was an appealing place, a city with a wide waterfront promenade lined with grand hotels, open markets, a boat-filled harbor, generally pleasant winter weather, and a lively social season. Matisse's health benefited from the change; he took up rowing, bought a car and learned to drive, and led a very regular life. He rose early and practiced his violin for several hours in a remote bathroom of the hotel (so as not to disturb the other guests). After spending the morning hours painting or working from a model, he took a stroll after lunch and returned to work from four in the afternoon until sundown; after that he would draw. Matisse also went to the movies frequently, and would travel along the coast to visit friends. The painter Pierre Bonnard, with whom he also corresponded, was at Antibes, and the old Impressionist painter Renoir was at Cagnes. His children also came from Paris to visit, and Marguerite often modeled for him.

These years also saw for the first time a number of books and monographs published on his art, and, in 1920, Matisse designed sets and costumes for the Russian ballet impresario Sergei Diaghilev's *Song of the Nightingale*. (In 1938, he tried his hand at scenery and costume design again for *The Red and the Black*, a ballet created by American choreographer and dancer Léonide Massine with music by the Russian composer Dmitri Shostakovich. The ballet was performed in Monte Carlo in Monaco, New York, and Paris, and was a great success.)

He also traveled briefly to London, and spent some weeks painting at Étretat on the coast of Normandy, a spot favored by the Impressionist painter Claude Monet. In December of 1923, Matisse's daughter Marguerite was married to Georges Duthuit, a writer and art historian. His friend Marquet was a witnesses, as were long-time patrons Michael and Sarah Stein.

The work of Matisse's Nice period is more relaxed, less abstract, and more filled with the comforting and appealing details of everyday existence. These paintings were immediately popular with the public and finally brought him the recognition and public approval he had long been denied in France, and his prices rose accordingly. His paintings of the period are often indoor scenes, models dressed up, or undressed, in oriental costume surrounded by elaborate patterns of screens,

Music

1939, oil on canvas;

45⅜ x 45⅜ in.

(115.2 x 115.2 cm).

Room of Contemporary Art

Fund, Albright-Knox Art

Gallery, Buffalo, New York.

Matisse returns once again to the theme of music in this lively image of two women—a guitar player and her audience. Progress photographs show that Matisse struggled to perfect the visual relationship between the figures. The curve of the guitarist's hip echoes the form of the body of the guitar, while the eye is drawn by the red background with its zigzag of white, a pattern continued by the yellow trim on the hem.

> **66** *Without passion, there is no art. The artist to a greater or lesser degree dominates himself, but it is passion which motivates his work.* **99**
>
> —HENRI MATISSE
> IN AN INTERVIEW WITH RUSSELL WARREN HOWE (1949)

Decorative Figure on an Ornamental Ground

c. 1925–26, oil on canvas; 51⅛ x 38⅝ in. (130 x 98 cm). Musée National d'Art Moderne, Centre Georges Pompidou, Paris. Critics agree that this painting is a culmination of everything Matisse was striving for during the Nice period—pattern, the beauty of everyday objects, the sensuality of the female nude, and monumentality.

rugs, fabrics, and wallpaper. The light of Nice filters through the window shutters or pours through French doors.

The paintings provided a healing fantasy that life was good and pleasurable—in years that were in reality grim with war and its aftermath. They are necessarily, perhaps, the fantasies of a middle-aged man, imbued with a not-so-subtle eroticism. However, they are tasteful, decorative, and skillfully and beautifully executed fantasies that transcend the ordinariness such fantasies might have in the hands of a less skilled or less creative artist—and bridge the gap from the personal to the universal.

Actually the Nice paintings encompass a range of visions, from the charming "plumed hat" drawings and paintings (1919), which show the young model Antoinette Arvoux posing in a white-plumed hat that Matisse himself had trimmed, to the intellectualized and schematic nude of *Decorative Figure on an Ornamental Ground* (c. 1925–26), in which the seated woman and her patterned surroundings have become for the artist, a complex pictorial problem that has little to do with female flesh.

THE NICE STYLE

The Nice style took shape quickly, as in a short period Matisse moved away from the abstract, architectonic style of *The Piano Lesson* (1916) and into the everyday delights of *The Music Lesson* (1917), with remarkably little apparent struggle. This was a period for him of self-indulgence, of allowing himself to paint the subjects and qualities that appealed to him most personally. The staged, artificial atmosphere of "odalisques" (female slaves or concubines in a harem) that Matisse creates in these paintings came partially from an attempt to recreate the atmosphere of light, pleasure, and indulgence that he had come to associate with his stays in Morocco. He recalled, "As for odalisques, I had seen them in Morocco, and so was able to put them in my pictures back in France without playing make-believe." However, he also recalled the light that came through the shutters in his waterfront room at the Hôtel de la Méditeranée: "It came from below, like stage lighting. Everything was fake, absurd, surprising, delicious." Certainly there is an element of the make-believe and the theatrical in this group of paintings.

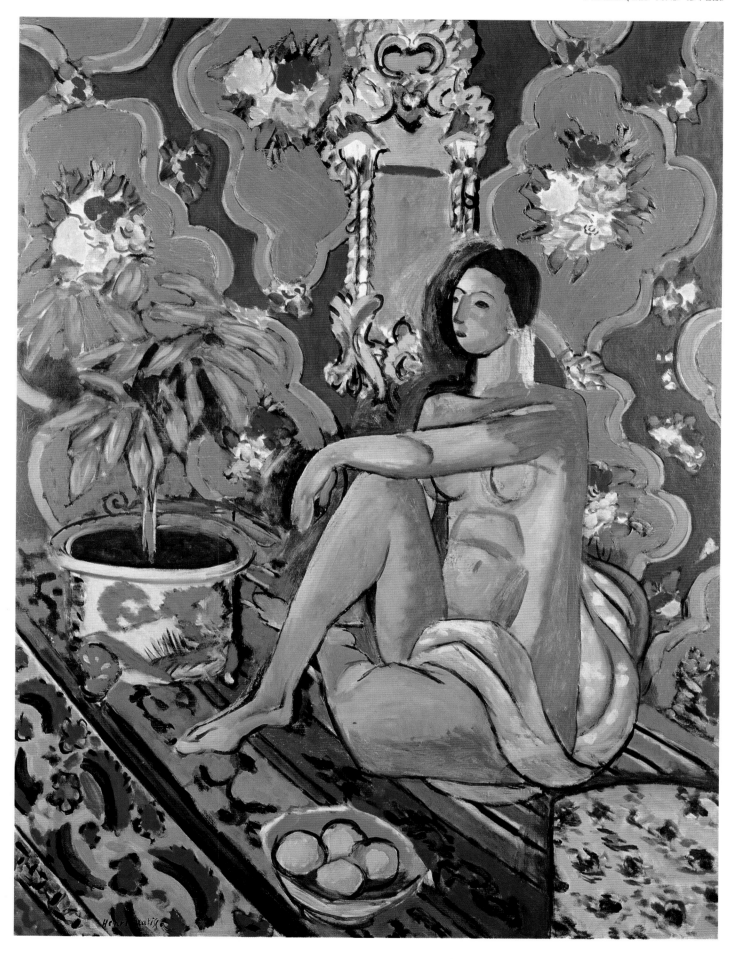

Not just the nudes and odalisques, but his portraits of his wife and daughter, the views out the window and from the balcony, and the still lifes of the first half of the 1920s all have an accessible, light-filled quality, busy with pattern and radiating sensual delight. Matisse found a particularly pleasing model, Henriette Darricarrère, and kept her employed for seven years. According to art historian Hayden Herrera, "She enjoyed role-playing in his imaginary harem, and her dramatic flair encouraged him to make his art into an exotic spectacle." Henriette modeled for *Odalisque with Red Culottes* (1921), the first work by Matisse to enter a French museum—it was acquired by the Luxembourg Museum in Paris in 1922.

The odalisques are the opposite of portraits—they are women's bodies used, in the most literal sense, as still life objects. The models themselves have little or no psychological individuality. Matisse generally underplayed his erotic preoccupation with his models, but a letter he wrote to his friend Camoin in 1918 regarding a new model leaves little doubt about his true state of mind: "She is a big sixteen-year-old girl, a colossal woman, she has tits like two liter Chianti bottles." But if women were still life objects in Matisse's works of this period, they were also actors—for as he later stated: "The object is an actor: a good actor can have a part in ten different plays: an object can play a role in ten different pictures."

A GROWING REPUTATION

For Matisse, the year 1924 was one of both retrospectives and recognition. He exhibited a number of works at the Joseph Brummer Galleries in New York, had another one-artist

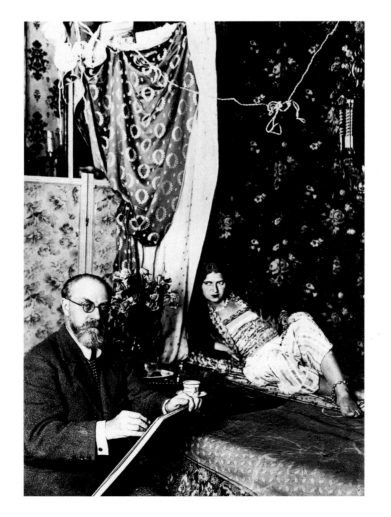

Matisse Drawing a Model at No. 1, Place Charles-Félix, Nice

c. 1927–28, photograph. Archives of the Museum of Modern Art, New York. The manner in which Matisse constructed the fantasy world of his odalisques is revealed in this photograph of the period. The artist sits drawing while a model in exotic costume reclines amidst an artificial bower of cushions and patterned draperies.

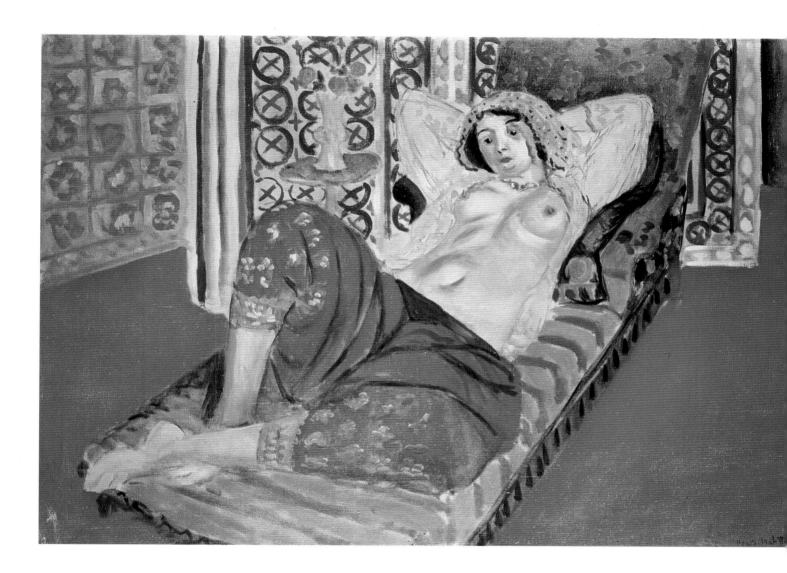

exhibition at the Bernheim-Jeune Gallery, and had his largest retrospective exhibition to date in Copenhagen, which subsequently toured to Stockholm and Oslo. The following year, his son Pierre went to New York and began working for the Dudensing Galleries. Here he began a career in the New York art world that would eventually lead him to open his own successful gallery. Pierre's move provided Matisse with a valuable New York

Odalisque with Red Culottes

1922, oil on canvas; 26⅜ x 33⅛ in. (67 x 84 cm).

Musée National d'Art Moderne, Centre Georges Pompidou, Paris.

Literally a harem slave, the odalisque became a symbol in Western art for a sexually available woman, and a convention for depicting female nudes in exotic settings. Matisse carried the tradition further than Delacroix and Ingres, making the odalisques part of his own personal vision of paradise.

> **"** *The exhibition of Henri Matisse's recent paintings at the Bernheim gallery is quite intriguing. The sun-soaked fauve has become a Bonnard kitten.* **"**
>
> —JEAN COCTEAU
> LE RAPPEL À L'ORDRE, "PROFESSIONAL DISTORTION" (MAY 12, 1919)

connection that soon bore fruit. In the winter of 1927, Pierre Matisse organized an important retrospective of his father's work at the Valentine Gallery in New York.

In the season of 1926–27 Matisse leased an apartment in Nice on Charles-Félix Place that remained his residence for the next ten years. Madame Matisse, meanwhile, maintained an apartment on the Boulevard of Montparnasse in Paris, where Matisse stayed with her when he was in town. This arrangement endured until 1928 when she moved into the apartment in Nice. More publications on Matisse's work and exhibitions followed as his career continued to flourish. By 1930, when his work was represented in the exhibition "Paintings in Paris from American Collections" at the new Museum of Modern Art in New York, his work was in five American and eight foreign museums. Besides the New York show, in 1930–31 there were comprehensive retrospectives of Matisse's work in Berlin, Paris, and Basel.

During the last years of the 1920s Matisse set aside easel painting in favor of printmaking. Although he continued to make prints and sculptures, he did not begin painting regularly again until 1934. Some of the prints

that Matisse produced at that time are lithographs, but the great majority are etchings and drypoints.

Matisse's most outstanding lithographs show subjects similar to the Nice paintings. They are richly modeled odalisques with oriental details and elaborate patterns. In 1930, Matisse agreed to illustrate a book of poetry by the French nineteenth-century poet Stéphane Mallarmé for the Swiss publisher Albert Skira. The twenty-nine etched illustrations that he produced are widely considered to be his greatest etchings—where he has reduced the curve of a back, the wave of a lock of hair, the feathers of a swan, to an essence of thin black line.

Matisse described his creative process thus: "I will condense the meaning of this body by seeking its essential lines." Writing about the experience of illustration, Matisse also said the "illustration of a book can also be an embellishment, an enrichment of the book by arabesques, in conformity with the writer's point of view." Matisse's working process of reduction and simplification can be seen by comparing his many detailed preparatory drawings to the completed illustration of *The Swan*. In the studies every feather and

Le Cygne (The Swan)

1931–32, etching for Poésies de Stéphane Mallarmé, *13⅛ x 9⅞ in. (33.2 x 25.3 cm).* The Louis E. Stern Collection, The Museum of Modern Art, New York. The expressive lyricism of Matisse's drawing is at its finest in these poetic illustrations. Matisse captures the essence of the swan with an economy of line that was possible only after he had made numerous detailed studies that revealed every muscle and feather.

Matisse in Tahiti

Spring 1930, photograph by F. W. Murnau.

The Museum of Modern Art, New York.

The Pacific island of Tahiti represented a kind of "paradise found" in Matisse's imagination. Although, as a tourist, he found life there less interesting than he had imagined, the impressions of tropical flora and fauna and the brilliance of tropical light that he brought back with him later blossomed into inspiration for his paper cutouts.

of my emotion." He compared the process of getting ready to make a pen drawing to the hours of limbering up exercises required by a dancer or tightrope walker. The beauty and expressiveness of Matisse's line is also readily apparent in the white on black linoleum cut illustrations he did for *Pasiphaé: Song of Minos* by the French writer Henry de Montherlant. These illustrations truly express the passionate nature of Montherlant's poetry.

TRAVEL AND TURMOIL

In 1930, Matisse traveled thousands of miles to fulfill a long-standing dream. Setting sail for the South Seas, by way of New York and San Francisco, he spent three months on the Pacific island of Tahiti, where Gauguin had come before him. He did no painting in Tahiti, but rather absorbed the atmosphere of tropical flora and fauna. He swam in the lagoon, he recalled, "among the coral colors, accented by the sharp

muscle is lovingly detailed while in the final etching, only the essential lines of the elegant bird remain.

Matisse's line drawings of the next two decades are a wonder of simplicity, confidence, and rhythm. They are a balanced expression of his classic ideal of beauty and his joy in the human form. Matisse's drawing style also had an enduring impact on future ideas about drawing and decoration. In *Notes of a Painter on his Drawing* (1939), Matisse wrote that his line drawings generate light and that they are "the purest and most direct translation

black of different sea-cucumbers . . . ," a "spectacle of luminous contrasts."

In Tahiti, Matisse made drawings of palm trees, canoes, flowers, and even an ornate little rocking chair. He found the life there dull, but the special light more than made up for the lack of excitement—for light had always been a central preoccupation for Matisse. He was familiar with the silvery northern light of Paris and Issy, the warm southern light of Nice and Morocco, and now he longed to see the golden light of the equator. He found it in the light of the Pacific Islands where "one

aintenant, toi, approche, fraîchie sur des lits de violettes.

Moi, le roi aux cils épais, qui rêve dans le désert ondulé,

moi, je vais rompre pour toi mon pacte fait avec les bêtes,

et avec les génies noires qui dorment la nuque dans la saignée

de mon bras, et qui dorment sans crainte que je les dévore.

Des sources qui naissent dans tes paumes je ne suis pas rassasié encore.

26

... fraîchie sur des lits de violettes...

"... fraîchie sur des lits de violettes"

1943–44, linoleum cut; illustration for Pasiphaé: Chant de Minos *by Henry de Montherlant; 12⅞ x 9¾ in. (32.7 x 24.8 cm).*

The Louis E. Stern Collection, The Museum of Modern Art, New York.

An elegant white line stands out against the black background of this print, which illustrates an erotic reverie containing the line "cooling on beds of violets." A woman hugs herelf as her long hair flows down in this evocative image.

seems to be looking into a deep goblet of gold."

On his way to Tahiti, Matisse had stopped in New York, where he was impressed by the glitter and the skyscrapers. "New York seemed to me like a gold nugget," he later recalled. He went to Pittsburgh, Pennsylvania, to help choose the prizewinner for the Carnegie International Exhibition (in which he himself had won first prize in 1927). This time the prize was awarded to Picasso. Matisse also stopped off in Merion, Pennsylvania, near Philadelphia to view the great art collection of his patron Dr. Albert C. Barnes. This visit led to an important commission, for Dr. Barnes asked Matisse to decorate the three interconnected arched spaces above the windows in the grand hall of his private museum.

THE MERION MURALS

Between 1931 and 1933, Matisse created the enormous work in an abandoned film studio in Nice he rented for the purpose. His first version (completed on schedule, in 1932) could not be installed, because of faulty measurements, but Matisse persevered, and in 1933 he created a version of the proper size which was installed in Merion. (The first version was not wasted; it was purchased by the Museum of Modern Art of the City of Paris in 1937.) For inspiration Matisse returned again to one of his great themes—the dance, which he had also used for Shchukin's murals. He took simplification farther than he had to date, reducing the monumental forms of the nude female dancers to a minimum of

Matisse at Work on the First Version of the Barnes Foundation *Dance* in His Temporary Studio at No. 8, Rue Désiré-Niel, Nice

1931; photograph. The Barnes Foundation, Merion, Pennsylvania. Matisse created full-scale drawings and studies for this large mural painting of stylized dancing nudes commissioned by his patron Dr. Albert C. Barnes. He secured large sheets of paper to the wall and drew on them using a piece of charcoal attached to a bamboo pole, so as to be able to stand back and see his lines effectively while he was in the process of working.

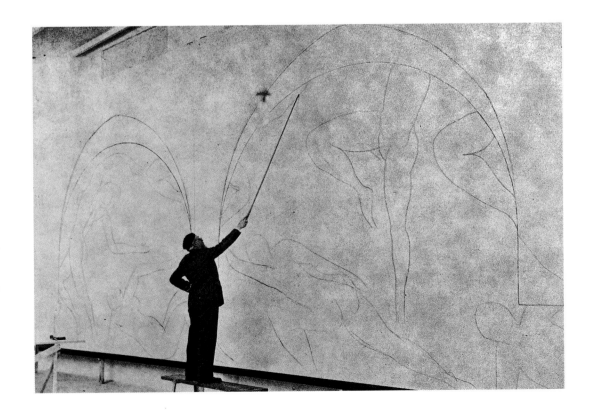

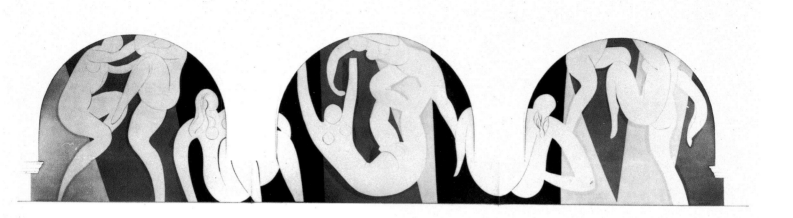

arabesques. The wildly moving dancers are painted in a light gray accented with a few well-chosen black lines, and they are set against a background of dark blue, pink, and black. Movements and body shapes echo the arches in which they are painted, and bodies are lopped off dramatically by the outer edge of the design, which can hardly contain the exuberance of their movements.

Matisse achieved the simplification of his design in part by his working method. He planned the composition in full scale (not in a sized-down model as was usual in such cases) by drawing with a piece of charcoal fixed to a 6-foot long (1.8 meter) bamboo pool. In this way he was able to stand back from the wall on which the paper was fixed, and truly see the effect of the lines as he made them. Dr. Barnes and Matisse were

both pleased with the installed murals, but they are perhaps not the most successful of Matisse's large works. They have been called brittle and flat, perhaps because of the simplified schematic drawing encouraged by the new bamboo pole technique—with which Matisse was not yet perfectly comfortable. They are also difficult to view as they are high on the wall and backlit by the glare from the windows.

Matisse did his best to work with adverse conditions. He subdued his ordinarily bright colors so as not to compete with the many fine Impressionist and Post-Impressionist works he knew to be displayed in the room, and used partial figures to give a feeling of vastness in a limited space. The viewing of the paintings is made difficult by an awkward perspective angle and the

**The Dance
(Merion Dance Mural)**

1932–33, oil on canvas; left: 133 3/4 x 173 3/4 in. (339.7 x 441.3 cm); center: 140 1/8 x 198 1/8 in. (355.9 x 503.2 cm); right: 133 3/8 x 173 in. (338 x 439.4 cm). The Barnes Foundation, Merion, Pennsylvania.

Many drawings and color sketches were required to complete this mural, which fits into the lunettes above three tall windows. The first version Matisse completed could not be installed due to faulty measurements and he was forced to repaint it entirely. Distilled to their simplest possible expression, the shapes of these energetic dancers communicate the artist's delight in the human form.

> 66 *Reduced by dint of simplicity to a few colored elements that call to, that answer one another, that sing to one another, each canvas shone like a child's dream.* 99
>
> —RENÉ SCHWOB
> *L'AMOUR DE L'ART,*
> *"HENRI-MATISSE,"*
> *(OCTOBER 1920)*

distraction of the green foliage outside the windows in summer, and the added light in winter. Matisse conceived the design to be viewed optimally, not from 18 feet below (5.5 meters) but at eye level from the second-floor balcony. Furthermore, the murals were the first great work of European art specifically commissioned in the United States.

AN INCREASING SIMPLICITY

Matisse's easel paintings of the early 1930s also show his tendency to distill and simplify in both form and color. *The Pink Nude* of 1935 is a revealing example of Matisse's painting development at this time because there are twenty-two black-and-white photographs of the painting in various stages of completion. The work began as a nude girl reclining on a sofa, still in fairly traditional perspective, but by the final version Matisse had eliminated the perspective in favor of flatness and changed the pose considerably. In fact, during the painting's progress, the nude changes from a passive odalisque to a large, spirited, and confrontational goddess— almost as if the act of being painted has given her life and strength.

Music (1939) and *The Rumanian Blouse* (1940) are also paintings typical of this new, more powerful vision. The women in paintings of this period have a more forceful presence and personality. These traits are communicated formally by Matisse's painting method—large areas of bright flat color and

bold black distorted outlines. Pattern is still used, but even that has undergone a shift toward simplification.

On the eve of World War II, Matisse's art, along with that of many other artists, was condemned by the Nazis as "degenerate." His work was removed from German museums and auctioned off in Switzerland. Personally, Matisse was greatly distressed with the menace of another war and found it difficult to concentrate on work. He went to the movies compulsively to ease his anxiety. On November 7, 1940, he expressed his feelings in a letter to Bonnard, writing "Doubtless our constant anxiety disturbs the unconscious work that customarily occupies us when we are no longer in front of the easel."

When the Germans approached Paris, Matisse was urged to go abroad. He was prepared to leave, and had obtained a visa for Brazil, but in the end he chose to stay and retreated again to the refuge of Nice. In Nice, Matisse continued painting until January of 1941, when, after a period of ill health, he underwent surgery for duodenal cancer followed by two pulmonary embolisms and a second operation. The Dominican nuns who nursed him did not think he would survive, but when he did, they nicknamed him the "Risen One." However, the muscles of Matisse's abdominal wall were severely weakened by the ordeal. Thereafter he had to wear a supporting belt and was not able to stand for very long.

The Rumanian Blouse

1940, oil on canvas; 36¼ x 28⅜ in (92 x 72 cm). Musée National d'Art Moderne, Centre Georges Pompidou, Paris.
A scarlet background enlivens this appealing work, which emphasizes the decorative embroidery and smocking of the model's blouse. The schematic and simplified style extends to the model's face and hands, which are communicated with great economy of line.

Large Reclining Nude (The Pink Nude)

1935, oil on canvas; 26 x 36 in. (66 x 92.7 cm). The Cone Collection, The Baltimore Museum of Art.
Matisse recorded the development of this painting with a series of black-and-white photographs that show the progression from a realistic figure to an almost abstract image. The process of developing the painting resulted in numerous changes of pose and distortions of form, as well as the reduction of realistic perspective to a flat and decorative suggestion of space.

Matisse Arriving in New York City on the S. S. *Mauretania*

December 15, 1930; photograph.
The Bettmann Archives, New York.
Matisse made stops in New York, Philadelphia, Pittsburgh, and San Francisco on his journey to Tahiti. He recalled "The first time that I saw America, I mean New York, at seven o'clock in the evening, this gold and black block in the night, reflected in the water, I was in complete ecstasy."

The Plumed Hat

1919, pencil on paper; 21¼ x 14⅜ in.
(54 x 36.5 cm). Gift of the Lauder Foundation,
Inc., The Museum of Modern Art, New York.
The model Antoinette Arvoux
posed for a number of drawings and
several paintings in a straw hat that
Matisse trimmed himself with white
feathers and black ribbon. Antoinette
undergoes many character transfor-
mations in these studies, from demure
adolescent to seductive beauty.

The Greek Torso and Bouquet of Flowers

1919, oil on canvas; 45¾ x 35 in. (116 x 89 cm). Museo de Arte, São Paolo.
The plaster cast of an antique female torso shares a table with
flowers in a vase while on the wall behind is pinned a drawing
of a kneeling woman whose posture seems almost to echo
the posture of the cast in reverse. The visual tie between
the drawing and sculpture makes an interesting counterpoint
in the painting—which is literally the third art medium.

**Matisse in His Fourth-Floor Apartment
at No. 1, Place Charles-Félix, Nice**

*March 1932; photograph. A. E. Gallatin Collection,
Philadelphia Museum of Art.*

Matisse stands surrounded by paintings which
include his own *Europa and the Bull* (1927–29) at
the upper left, Cézanne's *Portrait of Mme Cézanne*
(1885–87) above his head, and Cézanne's *Bibémus*
(c. 1904) at the upper right. Cézanne's work continued
to provide inspiration to Matisse throughout his career.

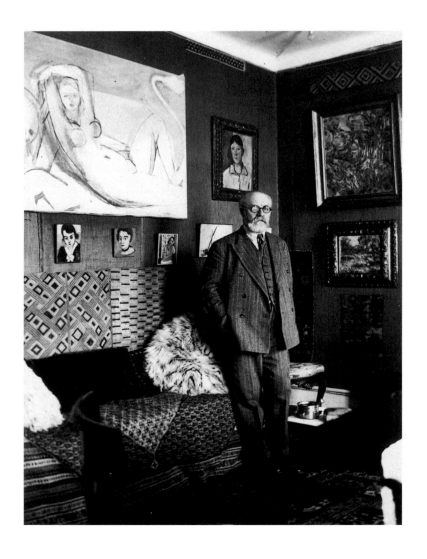

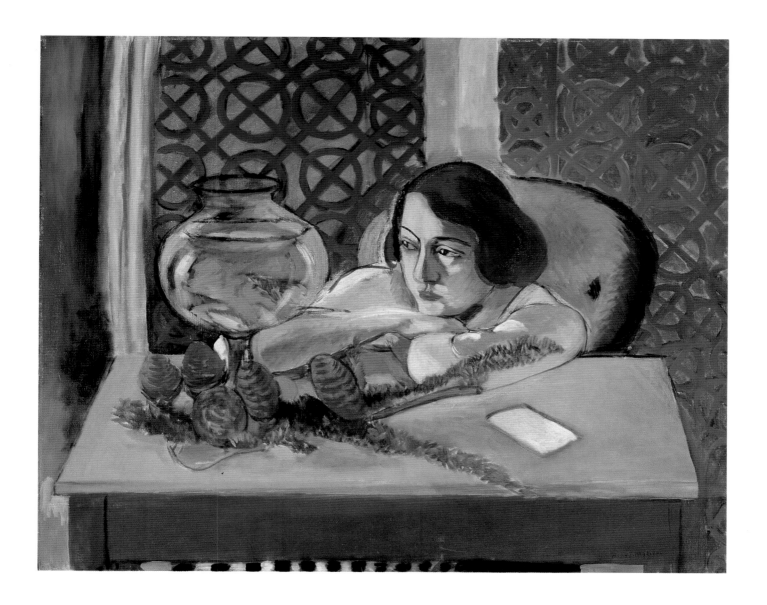

Woman Before an Aquarium

1923, oil on canvas; 31¾ x 39¼ in. (80.7 x 100 cm).

Helen Birch Bartlett Memorial Collection, The Art Institute of Chicago.

The intensity of the model's gaze—the concentration with which she
dreamily regards the goldfish swimming in their bowl—is unusual in
Matisse's art. It highlights the extent to which women are usually shown as
the objects to be looked at, rather than as active participants, in Matisse's work.

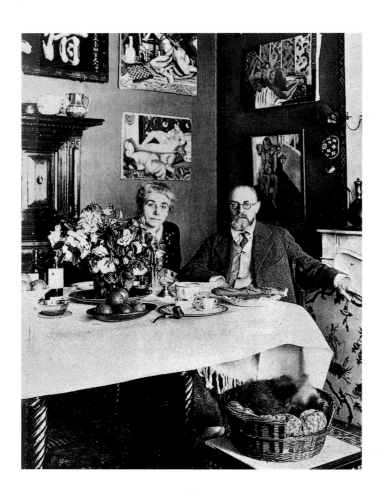

Matisse and Madame Matisse in the Dining Room of the Fourth-Floor Apartment at No. 1, Place Charles-Félix, Nice

c. 1929, photograph by Kate Keller. The Museum of Modern Art, New York. When living and working in hotel rooms became too inconvenient, Matisse rented an apartment in Nice, where he was joined in 1928 by Madame Matisse, who had been living in Paris. The Matisse's long marriage ended when they were formally separated in 1940.

Back (IV)

c. 1931, bronze, 6 ft.
2 in. x 44¼ x 6 in.
(188 x 112.4 x 15.2 cm).
Mrs. Simon Guggenhein
Fund, The Museum
of Modern Art, New York.
Monumentality and
simplicity define
this final relief
sculpture of the
Back series. The
female nude has
been reduced to
an impression of
two strong columns
bisected by the third
column of her long
hair. Her raised
arm is all that re-
mains of the once
graceful and gently
bending posture.

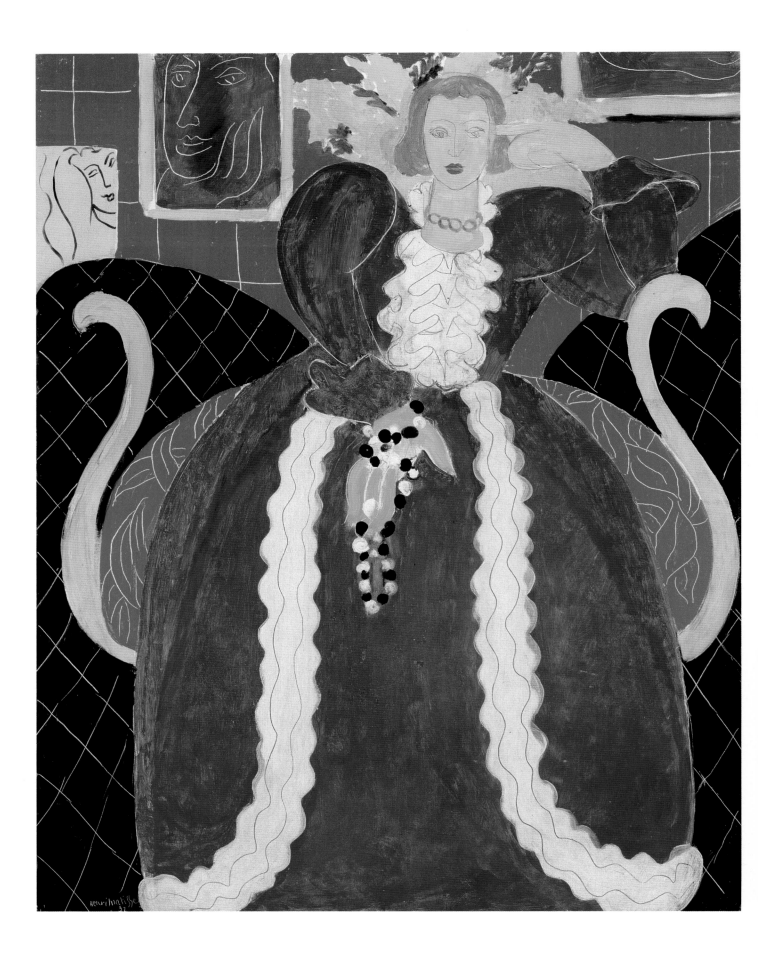

Matisse at Work on *Nymph in the Forest* in His Studio at the Hôtel Régina, Nice-Cimiez

August 1941, photograph by Varian Fry. Gift of Mrs. Annette Fry, The Museum of Modern Art, New York.

Matisse continued to paint despite war, illness, and disability. Here he perches on a step stool to reach the top of a large canvas filled with sexual energy on the theme of a nymph and satyr in the forest.

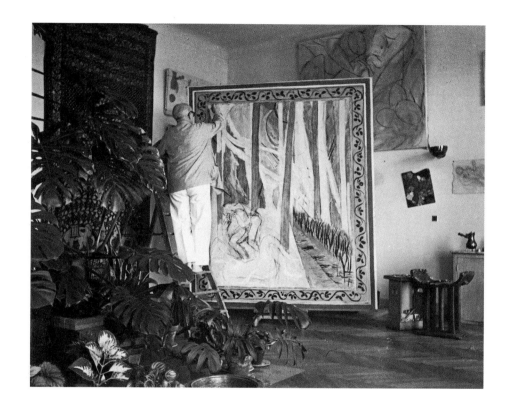

Woman in Blue/The Large Blue Robe and Mimosas

1937, oil on canvas; 36 x 29 in. (92.7 x 73.6 cm). Gift of Mrs. John Wintersteen, Philadelphia Museum of Art.

Matisse reworked a fairly conventional portrait into this charmingly decorative image, which has the flatness of a playing card, as well as its bright colors. Note the way the contrasting trim of the dress and the exaggerated forms of the hands, especially the one wrapped with beads, help to focus attention on the blue-robed woman instead of the background colors.

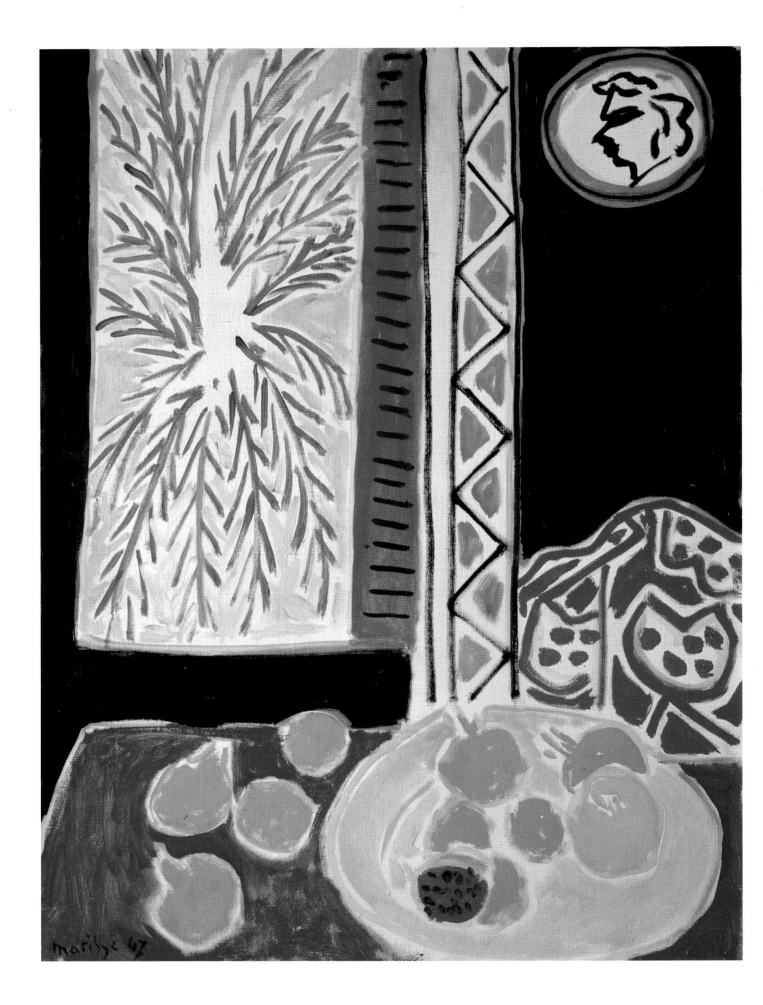

Chapter Five

THE SPIRIT OF LIGHT

Matisse's brush with death left him a semi-invalid until the end of his days. He found a way around his disability, however, with a determination to keep on creating, and reinvented for himself an ingenious solution that allowed him to continue making art—the paper cutout. He was also able to draw on the walls and ceiling from his bed using a long bamboo pole as his pen, a technique he had first found useful in his work on the Barnes murals.

RECOVERY AND RECOGNITION

Matisse was well looked after by his secretary and housekeeper, Lydia Delectorskaya, who had also modeled for him since the early 1930s. His devoted nurse, the Dominican novice Sister Jacques, also helped to speed his recovery. Matisse was able to paint, draw, and even sculpt from his bed as he convalesced, but by the late 1940s, he turned increasingly to cut and pasted paper as a new favorite medium. His paintings of the 1940s tend to be more abstract, with flat space, generalized light, and bright colors often contrasted with large areas of black.

Throughout World War II, Matisse was not overtly political, even during the time of increasing oppression under the Vichy government in France. Unlike Picasso, who became a symbol of the French Resistance,

Matisse lived quietly in Cimiez, a suburb of Nice, until an air raid caused him to move to the ancient hill town of Vence, about 20 miles away (32 kilometers). There, he settled into a small villa called Le Rêve ("The Dream"), where he remained until 1949, when he moved back to Nice-Cimiez to the Hôtel Régina.

Madame Matisse, who had legally separated from her husband in 1940, worked for the Resistance (the French underground movement) during the war. In 1944, Marguerite, also working for the Resistance, was caught and tortured by the Nazis and sent on a train bound for the Ravensbruck concentration camp. An Allied air raid, however, enabled her to escape from the train and she eventually made her way back to Paris. Madame Matisse, meanwhile, had been caught typing incriminating papers and was sentenced to six months in prison. Jean, who was mobilized at the start of the war, ended up using his cellar as a firearms training center for Resistance recruits, and also hid dynamite in his sculptures. Pierre had been allowed to return to the United States at the beginning of the war, and made an unsuccessful attempt to get Matisse to follow him.

In the years following the war, Matisse received more honors as an artist than he ever

Still Life With Pomegranates

1947, oil on canvas;

31½ x 23⅝ in.

(80 x 60 cm).

Musée Matisse, Nice.

Pattern is the subject of this painting, which is boldly composed with a wide stripe of print curtain and the explosive fronds of a palm tree just beyond the black window frame. A dish of fruit sits serenely on a tabletop, the cut pomegranate half echoing the other patterns in the room.

66 *It's rather the paper material which remains to be disciplined, to be given life, to be augmented. For me, it's a need for knowledge. Scissors can acquire more feeling for line than pencil or charcoal.* 99

—HENRI MATISSE
IN AN INTERVIEW WITH ANDRÉ VERDET (1952)

had previously. He was given a one-artist show at the Paris Autumn Salon of 1945, as well as a solo show at the Victoria and Albert Museum in London (simultaneously with Picasso). He also had large exhibitions in Brussels and Nice in 1946, and appeared in a documentary film called *A Visit with Matisse*, in which he talked about his paintings and drew a flower and a portrait of his grandson Claude on camera. Matisse was also honored by the French government by being elevated to the rank of Commander of the Legion of Honor (he had been named a knight or "Chevalier" in 1925). The newly formed National Museum of Modern Art in Paris began to purchase a number of representative works by Matisse, to correct their former oversight.

THE CUTOUTS

Matisse's cutout period began with his book *Jazz*, published by Tériade in 1947. The vibrant and compelling images that illustrate it were, literally, drawn with a scissors, while Matisse wrote the accompanying text out in a large cursive hand. He introduced his book with the following thought: "To cut right into color makes me think of a sculptor's carving into stone. This book has been conceived in this spirit." The images and the title are drawn from his memories of the circus, myths, and travel. The music analogy is strong, as it often is when he speaks of his art. He describes the illustrations for *Jazz* as "my chromatic rhythmic improvisations," and the written text as a "background of sound"—which is to provide a sort of walking bass line or counterpoint to the higher key and "vivid and violent" tones of color and form.

Matisse began to work on the *Jazz* illustrations in 1943, treating such themes as the Clown, the Circus, the Wolf, Icarus, Pierrot's Funeral, the Swimmer in a Pool, and the Cowboy. The forms and shapes in these illustrations describe reality in an abbreviated way, Matisse reduces the world he has seen to "signs," which he considers equivalents to

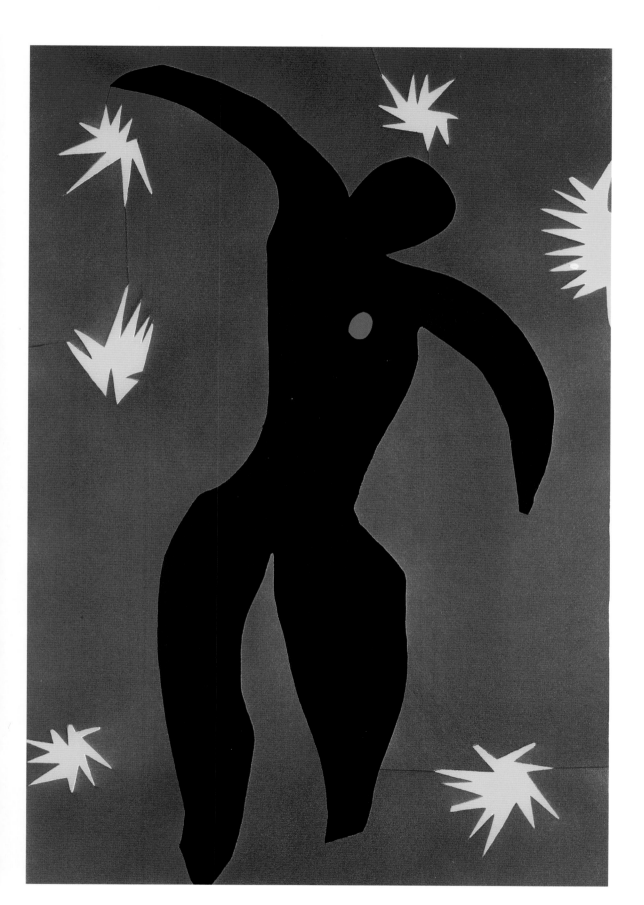

Icarus

1947; Plate VIII from Jazz ; each double sheet 16⅜ x 25⅝ in. (42.2 x 65.1 cm). Ecole des Beaux-Arts, Paris.

Matisse's book of bright paper cutouts on themes from myths, memories, and the circus introduced a significant new period of his work, in which he communicates human experience with pictorial signs. The myth of Icarus tells the story of a boy who with his father, Daedalus, flew in the sky wearing wings of wax and feathers. When Icarus did not heed his father's warning and flew too close to the sun, his wings melted and he fell into the sea.

nature, as well as a combination of painting and drawing. Matisse's "signs" are shapes that contain an unmistakable kernel of reality. An example he gave is fig leaves, which he maintained, are always unmistakable "whatever fantastic shapes they assume."

In the late 1940s, Matisse used his new cutout technique (which he had first used as a working tool while designing the Barnes murals) to execute commissioned designs for a number of tapestries and wall hangings. Most of these were on the theme of the plants and creatures of Tahiti, which were now enshrined in his memory as a taste of paradise. He returned to this theme again in 1953, a year before his death, in the almost abstract cutout composition *Memory of Oceania*. The delights of Tahiti had by this time grown large in his imagination—in 1947 he describes the effect of his visit: "The enchantments of the sky there, the sea, the fish, and the coral in the lagoons, plunged me into the inaction of total ecstasy."

Memory of Oceania

1953, gouache on paper, cut and pasted, and charcoal on white paper; 9 ft. 4 in. x 9 ft. 4⅞ in. (284.4 x 286.4 cm). Mrs. Simon Guggenheim Fund, The Museum of Modern Art, New York.

Along with the large cutout, *The Snail*, this late work was as close as Matisse came to approaching abstraction. He still refers to human and living forms, but only in the most symbolic and abbreviated way. The arrangement of color, shape, line, and edge—and the freedom with which they are used—is the primary subject of this composition.

The Beasts of the Sea

*1950, gouache on paper, cut and
pasted on white paper; 116⅜ x 60⅝ in.
(295.5 x 154 cm). Ailsa Mellon Bruce Fund,
National Gallery of Art, Washington, D.C.*
Matisse's memories of the sea
creatures he admired while
swimming in the lagoon in Tahiti
surface in this tall cutout, which
is designed in the same format as
a stained-glass window. The stylized
fish and other marine life forms
are reduced to abstract symbols that
are nonetheless extremely expressive.

RELIGIOUS WORKS

One of the great projects of Matisse's final years was his design of the Chapel of the Rosary of the Dominican sisters of Vence, a project he fell into almost by chance—and ended up not only completing without pay, but also personally contributing greatly to the expenses. Sister Jacques, who had nursed him after his operations, was serving at a nearby convent-run rest home for tubercular girls, and would often stop by to visit Matisse. One day she brought with her a watercolor design for a stained-glass window that was to be part of the new oratory of the convent, for the old one had been destroyed in a fire. Matisse was soon so interested in helping with the project that he began to design the windows himself.

Matisse's creative vision of the chapel, in which he immersed himself for the next four years, from furniture to every detail of interior and exterior decoration, won the approval of the Dominican order. Matisse's design concept relied on the stained-glass

The Dominican Chapel at Vence

Photo RMN—H. del Olmo.

Musée Georges Pompidou, Paris.

Matisse designed every element of this small chapel, from the delightful tree-of-life stained-glass windows, to the crucifix on the altar and the black line drawing of Saint Dominic, executed on glazed ceramic tiles. The colored light from the numerous windows creates an effect of beauty, awe, and spirituality.

❝ *These colors are of quite ordinary quality; they exist as an artistic reality only with regard to their quantity, which magnifies and spiritualizes them.* ❞

—HENRI MATISSE
WRITING ABOUT THE STAINED-GLASS WINDOWS OF THE CHAPEL AT VENCE, FOR THE CHRISTMAS ISSUE OF FRANCE ILLUSTRATION (1951)

Matisse in His Studio at the Hôtel Régina, Nice-Cimiez

August 1949, photograph by Robert Capa.

Magnum Photos, Inc.

Matisse is seen at work on a sketch for the tile mural *Stations of the Cross*, which he was designing for the Chapel of the Rosary at Vence.

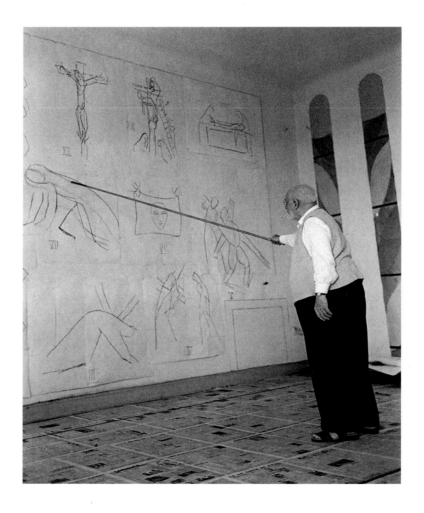

Interior of the Chapel at Vence

Photo RMN—H. del Olmo.

Musée Georges Pompidou, Paris.

At the left is Matisse's *Virgin and Child* in painted and enameled ceramic, to the right his schematic interpretation of the *Stations of the Cross*. Drawing from his bed with charcoal attached to a bamboo pole, Matisse executed these large works with a dignity and a simplicity that effectively convey their spiritual content.

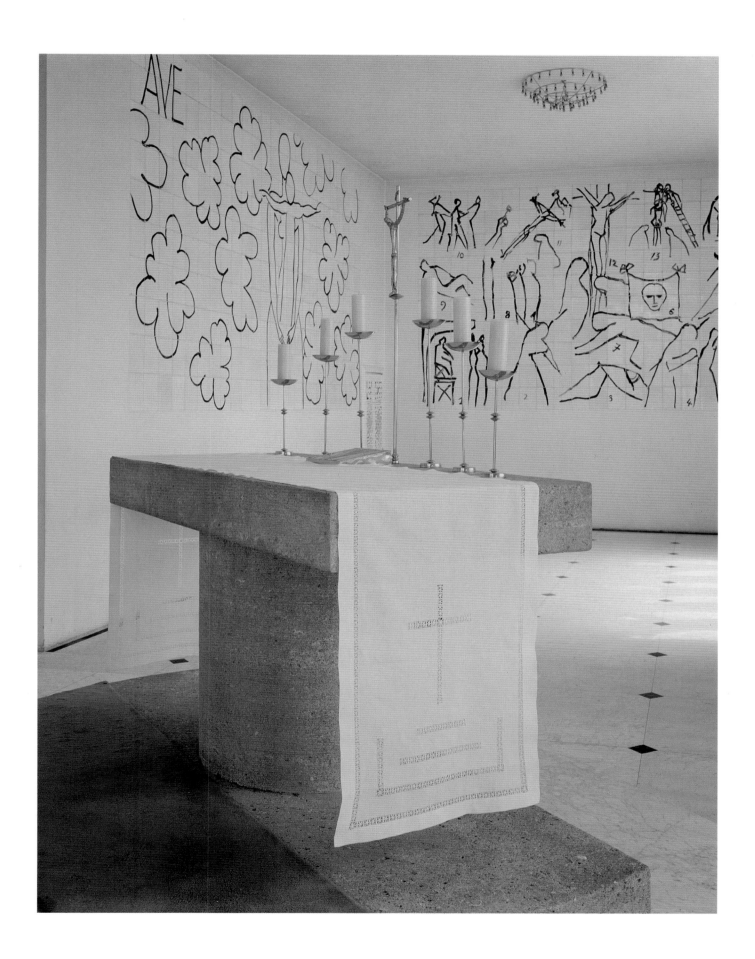

Maquette for Red Chasuble

*Designed for the Chapel of the Rosary of the Dominican Nuns
of Vence 1950–52; gouache on paper, cut and pasted; 52 in. x
6 ft 6⅛ in. (133.3 x 198.4 cm). Acquired through the
Lillie P. Bliss Bequest, The Museum of Modern Art, New York.*

Matisse may have designed as many as
nineteen chasubles, the sleeveless vestments
worn by Roman Catholic priests for cele-
brating the Mass, although only a few were
actually made (in silk). Matisse used his
cutout technique to create decorative
solutions that included symbolic images
of crosses, stars, fish, haloes, and palm leaves.

windows as a source of light and color.
The rest of the space he kept a pristine white
except for the altar and its furniture and the
huge black line drawings on the walls. The
stained-glass windows have a simple, elegant
"tree-of-life" motif with big leaves and bright
colors—golden yellow, deep blue, and grass
green. The wall drawings, which are actually
glazed tiles, were brushed by Matisse before
their final glazing.

Drawings adorn three walls of the chapel:
the themes are the *Stations of the Cross,
The Virgin and Child,* and *St. Dominic.* The

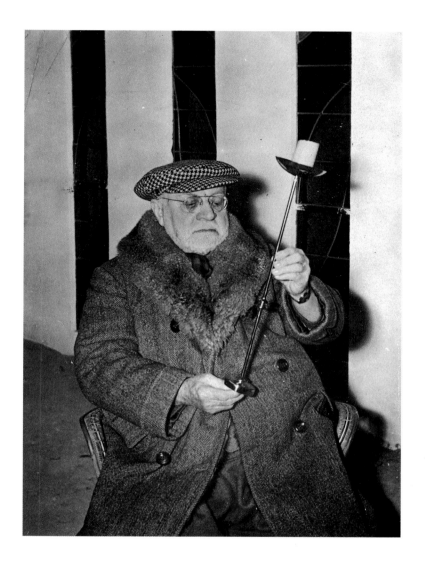

wall-sized drawings are elegant, schematic, and powerful. The figures of the Virgin, Child, and Saint are reduced to a symbolic minimum while the Stations of the Cross provide a numbered diagram in a shorthand drawing style that nonetheless communicates the essence of events. An atmosphere of spirituality is created by the colored light that floods into the chapel from the many windows and reflects off the tile walls and floor (which is also white, accented only by diamonds of black tile). Matisse's elegant hand is also visible in the altar and its furniture, the crucifix, chasubles, and various other details.

The completed chapel was consecrated on June 25, 1951. Although Matisse had been forbidden by his doctor to attend the ceremony, he received congratulations from his bed and was represented at the event by his son Pierre. In a letter to Bishop Rémond on this occasion, Matisse wrote that he considered the chapel "in spite of its imperfections, to be my masterpiece." To this the

Bishop replied, "The human author of all that we see here is a man of genius who, all his life, worked, searched, strained himself, in a long and bitter struggle, to draw near the truth and the light."

Matisse's only other religious work also dates from the Vence period. It is another *St. Dominic*, drawn in black on yellow tile which adorns the church of Notre-Dame-de-Toute-Grâce at Assy. He painted this altarpiece at a time when he was in the midst of his designs for Vence, and the piece clearly reflects the same style.

Matisse in the Chapel at Vence

c. 1952, photograph. The Bettmann Archives, New York. Designing the interior of the Chapel of the Dominican sisters of Vence was one of Matisse's last great undertakings. Although he was not strongly religious, Matisse found a renewed spirituality in the project that enabled him to execute designs of great simplicity and power.

FOLLOWING PAGE:

Interior of the Chapel at Vence

Photo RMN—H. del Olmo. Musée Georges Pompidou, Paris. This interior view of the Chapel at Vence shows the door to the Confessional. To the left is Matisse's *Virgin and Child*, to the right the *Stations of the Cross*.

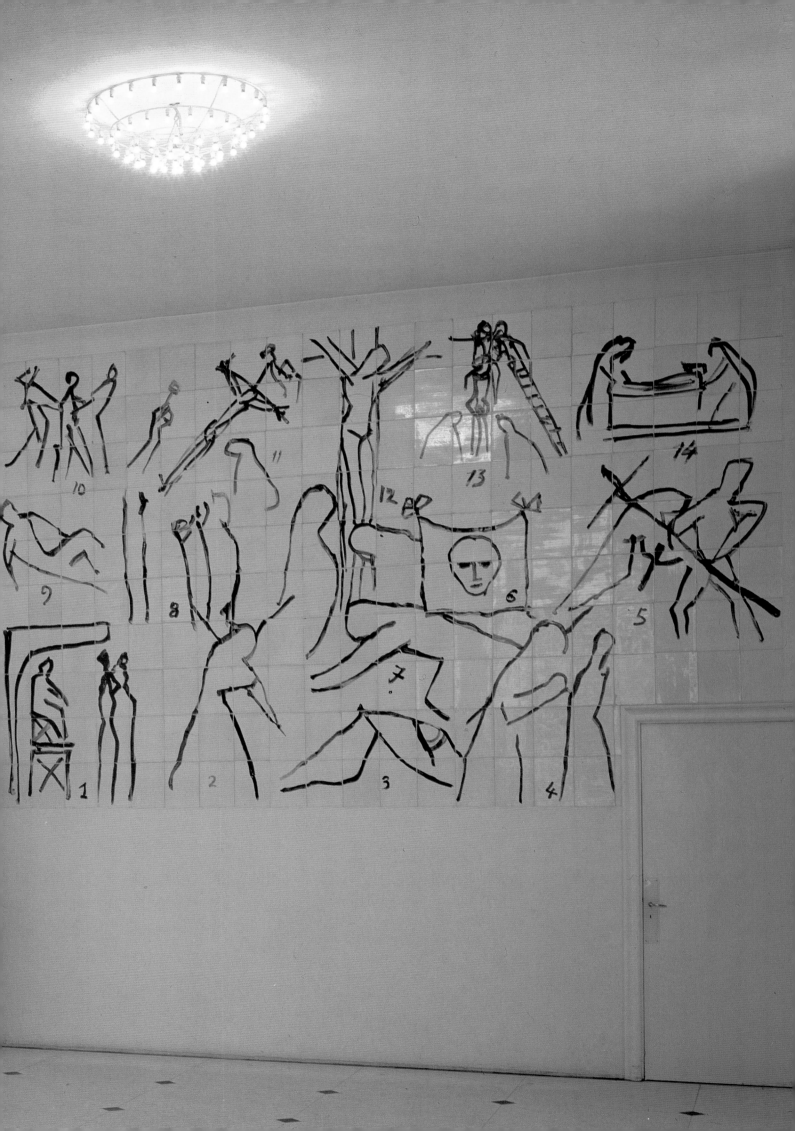

THE FINAL YEARS

In his final years, Matisse received the attention and honors befitting an artist of his stature. Several important exhibitions of his work occurred around the time of his eightieth birthday. A large retrospective of his work was held at the Philadelphia Museum of Art in the spring of 1948. His paper cutouts were shown for the first time at the Pierre Matisse Gallery in New York in early 1949, inspiring the art critic Clement Greenberg to describe him as the greatest living painter.

Then, in June of 1949, an exhibition of his recent works opened at the National Museum of Modern Art in Paris, including a number of paper cutouts and many of the preparatory studies for the Vence Chapel. This exhibition coincided with a large Matisse retrospective at the Museum of Beaux-Arts in Lucerne, which also included a survey of his sculpture. In 1950, he had several more exhibitions in France, and represented his country at the twenty-fifth Biennale in Venice, where he was honored with first prize.

In 1951 there was a large exhibition of his work at the National Museum in Tokyo, which traveled to the cities of Kyoto and Osaka. He had German exhibitions in Hamburg and Düsseldorf. In 1951–52, a large retrospective of Matisse's work was held at the Museum of Modern Art in New York, which subsequently toured to Cleveland, Chicago, and San Francisco. The year 1952 also saw the publication of Alfred H. Barr, Jr.'s comprehensive monograph: *Matisse: His Art and His Public*. Then, in November of 1952, the Matisse Museum in his birthplace of Le Cateau-Cambrésis was inaugurated, followed in 1953 by a large exhibition in London at the Tate Gallery, and another retrospective of his work in Copenhagen. Matisse died of a heart attack in Nice on November 3, 1954. He was buried at Cimiez on November 8.

During his last years, Matisse was profoundly creative and productive. He made mostly large-scale paper cutouts. Assistants would paint paper according to his instructions, he would cut it, and then direct them where to paste it in his compositions. He worked in tall formats such as *Christmas Eve*, a commission for *Life* magazine that had been inspired by his work on the stained-glass windows of Vence, and also in long horizontal formats, such as *The Swimming Pool*, which stretched the length of the walls of his dining room. From this period come works such as the *Blue Nude* series (1952), which have become some of his most popularized images.

Photographs from this period show his studio and apartment at the Hôtel Régina lined from floor to ceiling with the large cutouts and drawings of this last period. Matisse lived with his pet exotic birds and tropical plants, as well as in the midst of his creations. In this fantastic garden of the imagination that blossomed incredibly in his final years, all the struggles, the earlier formal concerns, fell away in a creative rebirth and freedom—perhaps possible for him only because he was so near death. There is a spirit of light and joy in these last works, an innocence in which Matisse finds the courage, in his words of 1953, to "look at everything as though he saw it for the first time" . . . to look "at life with the eyes of a child."

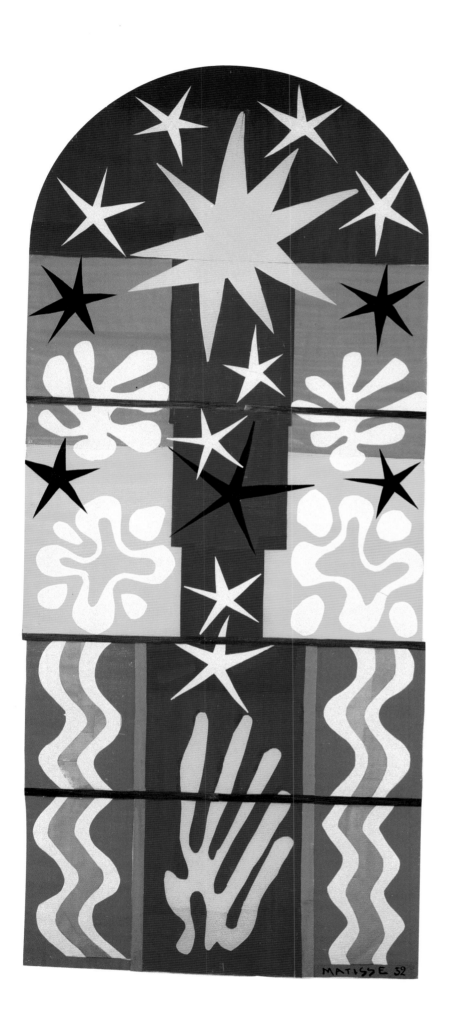

Christmas Eve

*1952, maquette for a stained-glass
window: gouache on paper, cut and pasted;
10 ft. 7 in. x 53 in. (322. 6 x 135.9 cm). Gift of
Time Inc., The Museum of Modern Art, New York.*
Commissioned by Time Inc., this
model for a stained-glass window
has bold colors and lively shapes that
suggest stars, leaves, and a mood of
celebration. When Matisse wrote
in 1939 that his drawings generated
light he had not yet created this win-
dow design, but it is certainly an apt
description of this joyful late work.

123

**Matisse
Reading in His
Studio at the Villa
Le Rêve, Vence**

*c. 1945, photograph by Thérèse
Bonney. The Bancroft Library,
University of California, Berkeley.*
Matisse sits at ease sur-
rounded by a selection
of his work. At the top
left is the painting,
The Dream (1940), and
next to it *Still Life with
Magnolia* (1941). At
the far right, cages hold
some of his beloved
collection of exotic birds.

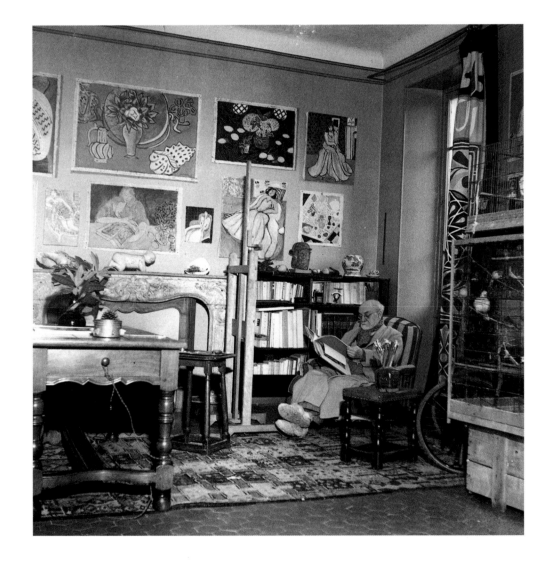

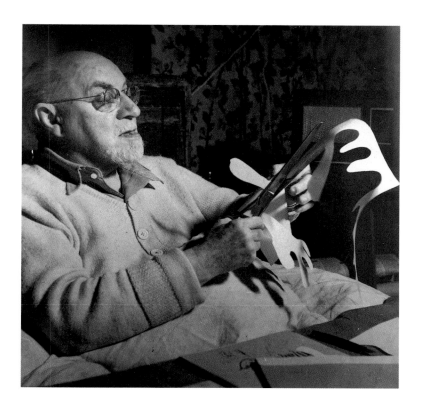

Matisse Working on a Paper Cutout

c. 1954, photograph. The Bettmann Archives, New York.

Matisse felt that scissors "can acquire more feeling for line than pencil or charcoal." In the last years of his life, when he was growing weak physically, he found that "sculpting" with paper enabled him to produce large works that distilled his vision magnificently and gave his creative spirit even greater freedom.

66 *In describing what he had aimed*

at in his painting, he mostly used music

as a metaphor—chords, singing colors,

and so on. 99

—JANET FLANNER
MEN AND MONUMENTS, "KING OF THE WILD BEASTS" (1957)

Sorrow of the King

1952, gouache on paper, cut and pasted; 115 x 155⅞ in. (292 x 396 cm).

Musée National d'Art Moderne, Centre Georges Pompidou, Paris.

The theme of music once again provides inspiration, this time for one
of Matisse's last large-scale figurative works. Human forms, reduced to
a few essential arabesques of cut and pasted paper, represent a drummer,
a stringed instrument player, and a woman dancing—amidst a flurry of
yellow leaf forms and bright colors recalling Matisse's Moroccan sojourn.

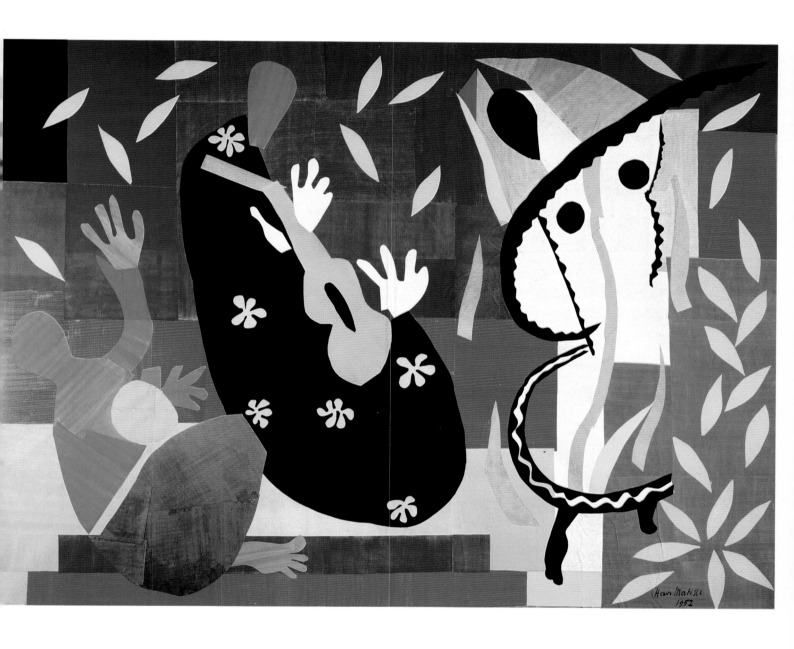

INDEX